CRAZY HORSE

A Photographic Biography

Bill & Jan Moeller

Mountain Press Publishing Company

Missoula, Montana

2000

Library of Congress Cataloging-in-Publication Data

Moeller, Bill, 1930–
 Crazy Horse : a photographic biography / Bill and Jan Moeller.
 p. cm.
 Includes bibliographical references and index.
 ISBN 0-87842-424-5 (alk. paper)
 1. Crazy Horse, ca. 1842–1877. 2. Oglala Indians—Biography.
3. Oglala Indians—Pictorial works. I. Moeller, Jan, 1930– II. Title.

E99.03 C7248 2000
978.004'9752'0092—dc21
[B] 00-010744

PRINTED IN HONG KONG BY MANTEC PRODUCTION COMPANY

Mountain Press Publishing Company
P.O. Box 2399 • Missoula, MT
(406) 728-1900

Contents

❧ Preface ❧

It was reading *Crazy Horse, The Strange Man Of the Oglalas* by Mari Sandoz many years ago that set us on the path to this book. As we delved further into the subject of Crazy Horse, we found very few books had been written about him; Sandoz's outstanding work is the best and most detailed account of his life. Our book will add to the works on Crazy Horse and will, we hope, because of its unique format that couples biography with color photographs, provide the subject with an expanded dimension. Most biographies, especially those of historical characters, use only old black and white photographs, if photographs are used at all.

Sandoz and others who have written about Crazy Horse display some bias about whether or not he was a hero. In material that relied heavily on army reports, he has often been portrayed as an intractable, white-hating savage. Yet if writers work primarily from interviews with those who knew him and lived with him—both Indians and whites—he invariably comes across as kind, gentle, understanding, generous, and concerned only for the well-being of his people.

We have used both types of material in our research and have developed our own biased opinion. Even though we have tried to tell Crazy Horse's story in as straightforward a way as possible, it will be obvious that we admire Crazy Horse and the way he lived his all too short life.

Much about the life of Crazy Horse is a mystery. No artifacts exist that can be positively ascribed to him. There are no accurate likenesses of him because he never sat for a portrait or allowed himself to be photographed. A few photographs are purported to be of Crazy Horse, but they are not. The only way to get an idea of what he looked like is to rely on descriptions from those who knew him; however, many of the descriptions differ as to his height, facial features, hair color, and the type of clothing he wore.

Precise details about much of his life will never be known. Chroniclers of Crazy Horse put his birth date anywhere from 1839 to 1845. Little is known of his childhood except for

the tribes he was with; his parents were with these tribes so we must assume Crazy Horse was, too.

His adult years, when his exploits made him known among Indians and whites, are well documented, as are the events surrounding his death. But then the mystery begins again: there are several opinions about where he is buried. Because of this lack of certain information, we, like other writers, have had to make assumptions in order to present a complete biography.

Some details about the Battle of the Little Bighorn also remain uncertain. Because no whites survived to tell what actually happened, questions about the movement and exact deployment of Custer's troops, and the times at which these occurred, are also unanswered. Again, we have made assumptions based on our research. As one authority told us, "Your guesses are as good as anyone's."

Crazy Horse's name in the Lakota language is Tasunke Witko. *Sunke* means "dog"; *tasunke* means "large dog" and is the Lakota word for horse. *Witko* does not mean crazy in the sense of insane, according to one Lakota we talked with; the closest he could come to describing the word in English was "enchanted" or "mystical." Another Lakota said it meant, in English, something akin to "untamed" or "unbroken." Many theories have been voiced about how Crazy Horse received his name, the most prevalent being that a wild horse ran through his village when he was born. While it is true that Indians were often named for an event, the fact is, Crazy Horse's father and grandfathers had also been named Crazy Horse. What event or circumstance caused the first Crazy Horse to be so named will never be known.

In telling the story of Crazy Horse, we tell as well the story of the Lakota people and their struggle for the freedom to maintain their way of life.

Acknowledgments

Many people aided us in compiling this book. Those with the National Park and United States Forest Services and the Bureau of Land Management, as always, were especially helpful: Jim Court; Neil Mangum; Mardel Plainfeather; Kitty Deernose; Will Schultz; Fred Dauber; Craig Bromley; Paul E. White, Sr.; Gary K. Howe; John Burns; Rick Lemmler; John Hamilton; Dennis Holkovic; and Homer Robinson.

Those affiliated with state historic sites were most accommodating: Ed Smyth, Delores Dalton, Charles Rambow, Craig Pugsley, Karen Schultz, Mark Hughes, Dennis Shimmin, Jeri Cutsor, Randy Wuertz, and Vance Nelson.

We appreciate the help ranchers, farmers, and landowners gave us by allowing us access to their lands: Mrs. Caroline Sandoz Pifer, Mrs. Mabell Kadlecek, Mick and Angel Franey, Ron and Kay Carlson, Frances Eller, Janette Chambers, Carl Soderberg, Dave Wisseman, Clara and Terry Jenkins, Gene and Donna Lehman, Kay Lohof, Gilbert Birdinground, and the Bailey, Knapp, and Lermany families.

We depend on libraries for much of our research. Our thanks to the librarians and staff at all the libraries we visited, and special thanks to those at the Scottsbluff Regional Library in Scottsbluff, Nebraska; the library in North Platte, Nebraska; the Johnson County Library in Buffalo, Wyoming; the Love Library at the University of Nebraska and the Nebraska Historical Society, both in Lincoln, Nebraska; and the Oglala Lakota College Library in Kyle, South Dakota.

Others who aided us in various ways are: Hildreth Milk, Donovan Shangreau, Tim Giago, Pete Mesteth, Bill O'Donnell, Jim Denney, Robert Savage, Charles Martin, and John Foote.

Without Bonnie Jensen, who took telephone messages and forwarded our mail to us while we were traveling, our job would have been impossibly complicated. We cannot thank her enough.

Our thanks also to those at Mountain Press who were involved with the book, especially Beth Judy, our editor, and Kim Ericsson, who was responsible for the layout and design.

Sites of Interest

Today, many of the lands once frequented by the Lakota are publicly held. Use the brief list of national parks, national forests, and state parks below to find out more. Look for links when accessing any of the websites, as many local museums and other attractions are referenced.

NATIONAL PARKS AND MONUMENTS

The National Park Service:
www.nps.gov/index.html

Bighorn Canyon National Recreation Area:
www.nps.gov/bica/
406-666-2412

Chimney Rock National Historic Site:
www.nebraskahistory.org
308-586-2581

Devils Tower National Monument:
www.nps.gov/deto/
307-467-5283

Fort Laramie National Historic Site:
www.nps.gov/fola/
307-837-2221

Homestead National Monument of America:
www.nps.gov/home/
402-223-3514

Little Bighorn Battlefield National Monument:
www.nps.gov/libi/
406-638-2621

Scotts Bluff National Monument:
www.nps.gov/scbl/
308-436-4340

Wind Cave National Park:
www.nps.gov/wica/
605-745-4600

NATIONAL FORESTS AND GRASSLANDS

Bighorn National Forest:
www.fs.fed.us/r2/bighorn/

Black Hills National Forest:
www.fs.fed.us/r2/blackhills/

Bridger-Teton National Forest:
www.fs.fed.us/btnf/
307-739-5500

Buffalo Gap National Grassland, west half:
www.fs.fed.us/r2/nebraska
605-745-4107

Buffalo Gap National Grassland, east half:
www.fs.fed.us/r2/nebraska
605-279-2125

Fort Pierre National Grassland:
www.fs.fed.us/r2.nebraska
605-224-5517

Little Missouri National Grassland:
www.fs.fed.us/r1/dakotaprairie
701-842-2393

Medicine Bow-Routt National Forests and Thunder Basin National Grassland:
Medicine Bow: www.fs.fed.us/r2/mbr/mbrwelcome.htm
Thunder Basin: www.fs.fed.us/r2/mbr/thunder.htm
307-745-2300

Nebraska National Forest
www.fs.fed.us/r2/nebraska
308-432-0300

Oglala National Grassland:
www.fs.fed.us/r2/nebraska
308-432-4475

Samuel R. McKelvie National Forest:
www.fs.fed.us/r2/nebraska
402-823-4154

Shoshone National Forest:
www.fs.fed.us/r2/shoshone/
307-527-6241

Sheyenne National Grassland:
701-683-4342

STATE PARKS

MONTANA
Montana Fish, Wildlife and Parks:
www.fwp.state.mt.us/parks/parks.htm

Chief Plenty Coups State Park:
www.fwp.state.mt.us/cgi-bin/park.pl?10
406-252-1289

Makoshika State Park:
www.fwp.state.mt.us/cgi-bin/park.pl?5
406-365-6256

Medicine Rocks State Park:
www.fwp.state.mt.us/cgi-bin/parks.pl?4
406-232-0900

Pictograph Cave State Park:
www.fwp.state.mt.us/cgi-bin/park.pl?9
406-247-2940

Rosebud Battlefield State Park:
www.fwp.state.mt.us/cgi-bin/parks.pl?3
406-232-0900

SOUTH DAKOTA
South Dakota State Parks:
www.state.sd.us/sdparks

Bear Butte State Park:
www.state.sd.us/gfp/sdparks/bearbutt/bearbutt.htm
605-347-5240

Custer State Park:
www.state.sd.us/state/executive/tourism/sdparks/custer/custer.htm
605-255-4515

Fort Sisseton State Park:
www.state.sd.us/gfp/sdparks/ftsiseton/ft_siss.htm
605-448-5701

WYOMING
Buffalo Bill State Park:
http://commerce.state.wy.us/sphs/buffalo.htm#Travel
307-587-9227

Curt Gowdy State Park:
http://commerce.state.wy.us/sphs/curt.htm#Travel
307-632-7946

Fort Fetterman State Historic Site:
http://commerce.state.wy.us/sphs/fetter.htm#Travel
307-358-2864
307-684-7629 (Off Season)

Fort Phil Kearney State Historic Site:
http://commerce.state.wy.us/sphs/kearney.htm#Travel
307-684-7629

Hot Springs State Historic Site:
http://commerce.state.wy.us/sphs/hot.htm#Travel
307-864-2176

Keyhole State Park:
http://commerce.state.wy.us/sphs/keyhole.htm#Travel
307-756-3596

Medicine Lodge State Archaeological Site:
http://commerce.state.wy.us/sphs/mlodge.htm#Travel
307-469-2234

❧ About the Photography ❧

As far as this book is concerned, a picture may not be worth quite a thousand words, but a photograph can convey more of a sense of place than most written descriptions. Over the years, in our reading about historical events, we often wanted a better description of a place than the author's writing conveyed. Now that we have visited many of the places we once saw only through an author's words, we have found that one writer's narrow canyon is, to us, a wide notch; the hill of another is not as high as we envisioned; and the hill of yet another is much steeper than his words conveyed. Even though the camera lens does not register a scene exactly as the human eye sees it, the photographs in this book should let the reader know what the sites and locations really look like.

It was our purpose to create a portrait of Crazy Horse by showing his country—where it is presumed he was born, where he lived, hunted, fought, and traveled, where he died, and, perhaps, where he is buried. But the locations of many events in his life are not known precisely. Through our research and exploration of the territory, we have determined where many of these locations logically would be; however, each photograph, exactly located or not, does depict some part of the country in which Crazy Horse lived. At one time or another he would have seen the scenes in each photograph.

As you read the story of Crazy Horse and look at the photographs, we ask you to envision many tipis on the flat lands by the rivers, with smoke rising from the campfires and ponies grazing nearby. Imagine if you will the dust and noise of fighting on the battlefields, and see in your mind's eye the magnificence of mounted warriors poised for attack, edging the crest of hills.

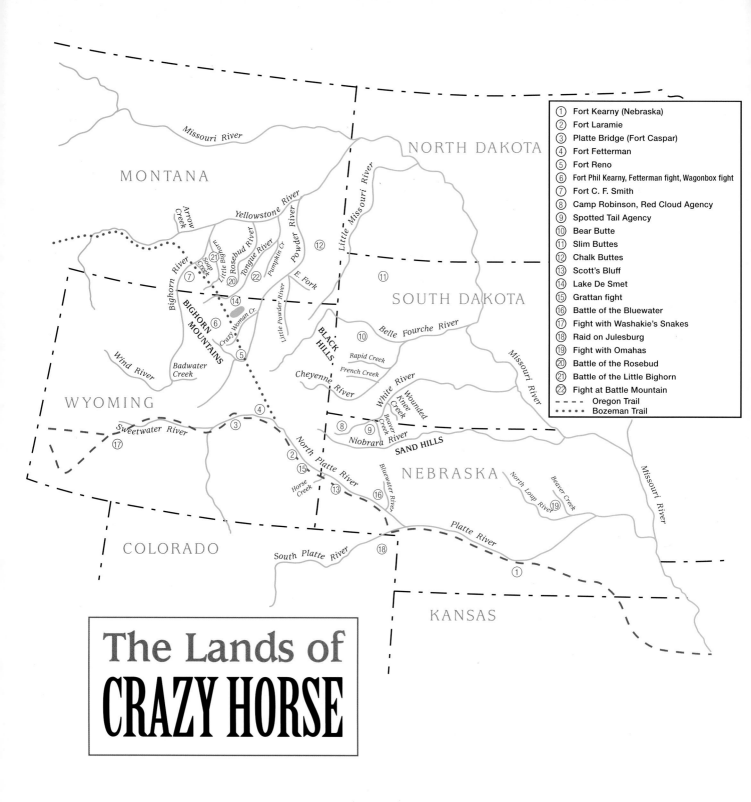

The Lands of
CRAZY HORSE

The following labels appear on the map:

Montana · North Dakota · South Dakota · Wyoming · Nebraska · Colorado · Kansas

Missouri River · Yellowstone River · Little Missouri River · Arrow Creek · Soap Creek · Little Bighorn · Rosebud River · Tongue River · Pumpkin Cr. · Powder River · E. Fork · Little Powder River · Bighorn River · BIGHORN MOUNTAINS · Crazy Woman Cr. · Wind River · Badwater Creek · BLACK HILLS · Belle Fourche River · Rapid Creek · French Creek · Cheyenne River · White River · Wounded Knee Creek · Beaver Creek · Sweetwater River · North Platte River · Horse Creek · Bluewater River · Niobrara River · SAND HILLS · South Platte River · Platte River · North Loop River · Beaver Creek · Missouri River

Legend:

1. Fort Kearny (Nebraska)
2. Fort Laramie
3. Platte Bridge (Fort Caspar)
4. Fort Fetterman
5. Fort Reno
6. Fort Phil Kearny, Fetterman fight, Wagonbox fight
7. Fort C. F. Smith
8. Camp Robinson, Red Cloud Agency
9. Spotted Tail Agency
10. Bear Butte
11. Slim Buttes
12. Chalk Buttes
13. Scott's Bluff
14. Lake De Smet
15. Grattan fight
16. Battle of the Bluewater
17. Fight with Washakie's Snakes
18. Raid on Julesburg
19. Fight with Omahas
20. Battle of the Rosebud
21. Battle of the Little Bighorn
22. Fight at Battle Mountain
- - - Oregon Trail
··· Bozeman Trail

Prologue

Long before the Sioux moved west, far past the Missouri River, in the latter years of the eighteenth century, they received their name. Their enemies, the Chippewa, gave them the derogatory name *Nadoweisiw,* which means "Lesser Adder" or "Snake." French trappers shortened the name to *Siw,* spelling it the French way, "Sioux"—the form used today.

The culture of the Sioux changed when they moved from the forested lands of the East. Out of necessity they became a nomadic people, following the buffalo. The shaggy beasts roamed the prairies in great dark herds often stretching farther than the eye could see.

The buffalo was the mainstay of the Sioux and other Plains Indians, providing them with food and other necessities. The people used the tanned hides for tipis, the sinew for sewing, the stomachs for cooking utensils, and the horns for tools.

The Indian tipi was a practical dwelling for nomadic life. Set up or taken down in minutes, it needed only to be rolled up and lashed to a travois for transport. It was warm in the winter with an inner liner that provided insulation and kept the wind out. In the summer, occupants could roll up the sides for ventilation.

The pattern of Sioux life depended on the season. In the summer, the people made raids against their enemies and hunted. Sometimes they held a council and a sun dance, attended by thousands. They spent the winters quietly in their tipi villages, which were situated next to rivers and sheltered from the north winds.

When he reached manhood, a male Lakota hoped for a vision that would show him how to live. A medicine man or holy man interpreted the mysterious, symbolic dream. Those who received great visions were revered by their tribe.

Children's physical features or events at the time of their birth influenced the names given to them. Names were always significant, but the reasons for bestowing them were not always clear. Individuals might have several different names during a lifetime. Elders sometimes passed their names on to young people, then chose a new name for themselves. When a great warrior died, others might take his name to honor him.

Sioux were individualists. As long as violence was not committed among kinsmen, tribal members could do what they wanted without censure and without anyone thinking the less of them.

Into this society, Crazy Horse was born. Crazy Horse was an Oglala Sioux. The Oglala are one of seven subdivisions of the Lakota, also called the Teton Sioux. The six other subdivisions are the Brulé, the Sans Arc, the Blackfoot Sioux, the Minneconjou, the Two Kettle, and the Hunkpapa. The Oglala are further divided into seven bands, one of which is the Hunkpatila, to which Crazy Horse belonged.

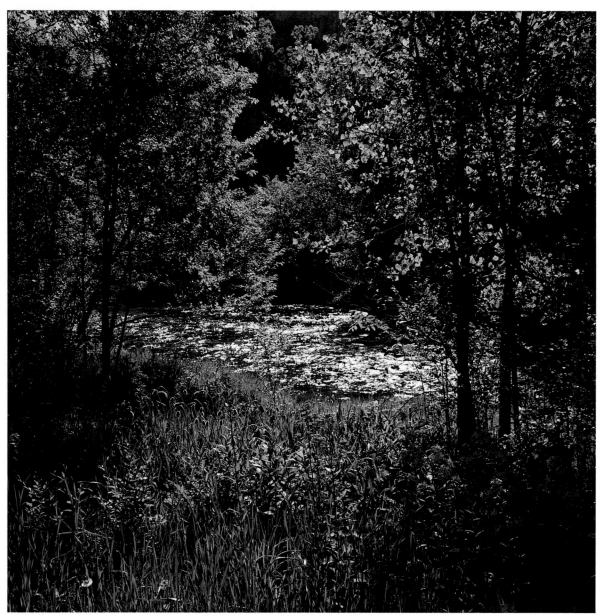

Rapid Creek, near Rapid City, South Dakota

✦ ONE ✦

The Boy Named Curly

Autumn 1842

After a summer council at Bear Butte—a holy place to the Lakota and their friends the Cheyenne—some of the Oglala moved south. They camped on Rapid Creek where it issued from Paha Sapa—the Lakota name for the Black Hills. Here they could replenish their supply of lodgepoles and be close to a trading post on the nearby Cheyenne River.

In this place, a son was born to the holy man Crazy Horse and his Brulé wife. The son was their second child; their daughter was two years old.

The boy came to be known as Curly because of the way his light brown hair fell in waves. His hazel eyes and light-colored skin were the first of many attributes that would set this Oglala, destined to become the famous war chief Crazy Horse, apart from his tribesmen.

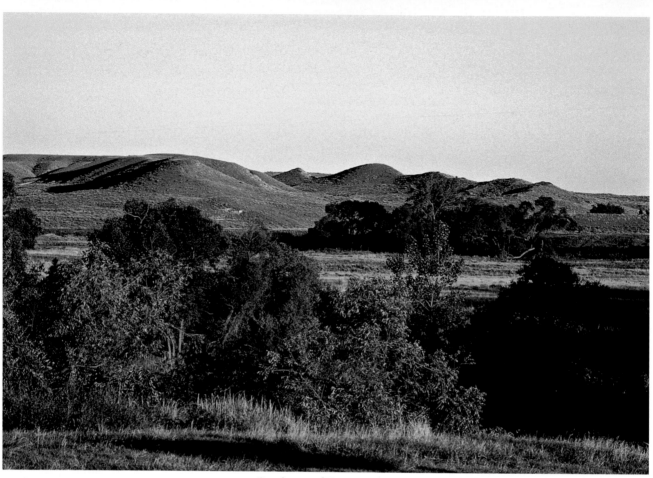

Southeast of Fort Laramie National Historic Site, Fort Laramie, Wyoming

1843–1849

After Curly's brother Little Hawk was born in 1843, their mother died. As was often the custom, their father married his wife's sister, Gathers Her Berries.

During Curly's childhood years, the tribe often camped on the North Platte River near Fort Laramie and Scotts Bluff. The Oregon Trail ran through the same area. Each year, ever increasing numbers of emigrants traveled west on the trail.

Indians from many tribes frequented Fort Laramie. They coexisted with the whites at the fort as well as with the emigrants or "overlanders," with whom they enjoyed trading. In the camps around the fort, Indian women made moccasins to trade to the emigrants whose shoes—after the many rough miles to Fort Laramie—were usually in a sorry state.

Overlanders were generally suspicious and fearful of Indians. But at this time, most troubles between them consisted of isolated incidents—usually harmless Indian pranks to which the whites overreacted.

These were good times for the Lakota—times of peace and plenty.

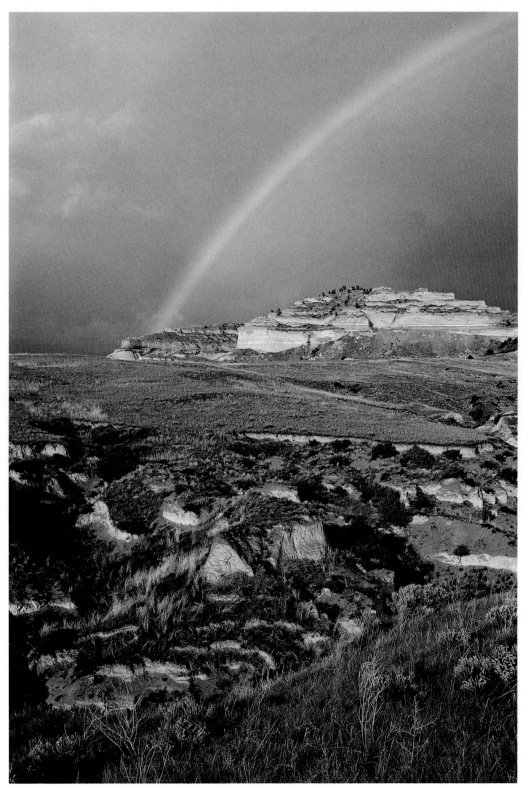

Scotts Bluff, Scotts Bluff National Monument, Gering, Nebraska

White Cliffs, north of Fort Robinson State Park, Crawford, Nebraska

Summer 1849

As emigrant travel over the Oregon Trail increased, so did cases of cholera. In this first year of the gold rush, the dread disease reached epidemic proportions among both whites and Indians. Seeking safety from the white man's disease, the Oglala and Brulé fled the region, traveling to the White Cliffs two hundred miles to the northeast. The cholera raged for a year.

To add to their woes, smallpox also broke out among the Indians.

Around the campfires, elders talked. They wondered why there had been no fearsome sickness until the white men came. Some even suggested the white men had worked magic and deliberately given them the diseases. Before this, young Curly had never heard his people speak against the whites. But now, listening, he began to wonder if what he heard was true.

8

October 15, 1849

Unaffected by disease, Curly and his immediate family stayed with the other Oglala and Brulé at the White Cliffs, near James Bordeaux's trading post on the White River. One autumn day a party of Crow—traditional enemies of the Lakota—raided Bordeaux's horse herd. For help in recovering his horses, Bordeaux rallied the Lakota, who were always eager to confront the Crow.

The Crow split their forces. One group drove the horse herd to safety. The other tried to hold off the pursuing Lakota, but were driven to the base of a high, flat-topped butte. Only one narrow path led to the top of the sheer formation; the Crow had no choice but to take it. Certain they had the Crow trapped on top of the butte, the Lakota planned to starve them out.

On the morning of the fourth day, the Lakota awoke to find rawhide ropes dangling from the top of the butte. To their shame, their enemies had escaped during the night.

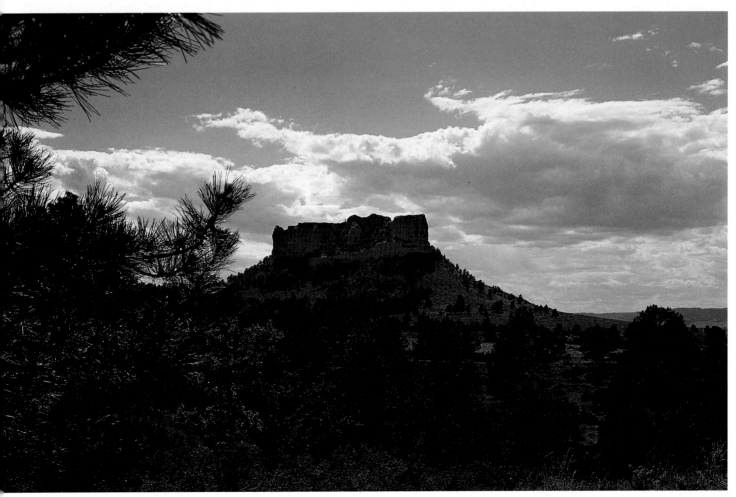

Crow Butte, near Crawford, Nebraska

Horse Creek, northwest of Scotts Bluff National Monument, Gering, Nebraska

August–September 1851

Because of the illnesses among their people, Oglala and Brulé chiefs began to talk of vengeance on the whites. To placate them, U.S. government officials sent word of a great council to be held at Fort Laramie; all who attended would receive gifts. Curly and his family decided to go.

Thousands of Indians from many tribes—including some enemies of the Lakota—converged on Fort Laramie in late August. The wagons carrying the gifts, however, had not yet arrived. They finally came in September. By that time,

seeking forage for their enormous pony herd, the Indians had moved to Horse Creek, thirty-seven miles east of the fort, where they camped on a great plain.

At the council, whites hoped to coerce tribal chiefs into signing a treaty guaranteeing unhindered passage to emigrants on the Oregon Trail. In return, the Indians would receive an annual dispensation of goods. The treaty also set forth tribal boundaries to prevent warring tribes from fighting in the vicinity of the trail.

Eventually the Indians signed the treaty.

1852–1854

Although tribal chiefs had agreed in good faith to the Treaty of 1851, many Indians could not resist the lure of the Holy Road. This was their sarcastic name for the Oregon Trail; the treaty forbade them to intrude upon it as if it were some holy, sacred place. To most Indians, stealing and harassment were games—a test of skill to see what they could get away with. But emigrants viewed such behavior differently, and reported many such "Indian incidents" to the commander at Fort Laramie.

Military leaders felt the Indians were getting out of control and needed to be taught a lesson. The Indians, on the other hand, were increasingly disgruntled. They talked among themselves about how the buffalo had begun to disappear after travel on the Holy Road began, and how whites were crowding Indians from lands they had once roamed freely, so they could no longer go where they pleased. Now, the 1851 treaty seemed restrictive.

Animosities began festering on both sides.

Near Big Springs, Nebraska

Grattan Massacre site, east of Fort Laramie, Wyoming

August 17, 1854

Brulé and Oglala—including Curly's family—were camped adjacent to the Oregon Trail on the south bank of the North Platte River a few miles east of Fort Laramie.

When a lame, trail-worn cow wandered into the Brulé camp, a visiting Minneconjou named High Forehead shot the miserable animal. It was cooked and eaten.

August 18, 1854

The cow's owner, an emigrant on the trail, had been afraid to venture into the Indian camp after it, but when he reached Fort Laramie, he reported the incident as a theft. The post commander, young Lieutenant Hugh B. Fleming, sent for Conquering Bear, the Brulé chief. Fleming demanded that the guilty party be brought to the fort. Wondering at the fuss over an old cow, Conquering Bear said he could not bring High Forehead in; he was not of his tribe. But as restitution, the Brulé chief said the cow's owner could have any of the ponies in his herd. Fleming refused the offer.

August 19, 1854

Lieutenant J. L. Grattan, just out of West Point and eager to prove himself against the Indians, set off from Fort Laramie to arrest High Forehead. With him marched thirty men with two pieces of artillery. On a small rise at the edge of the Brulé camp, they set up their field pieces.

For forty-five minutes, Grattan and Conquering Bear tried to persuade High Forehead to surrender. High Forehead told them he would not; he would rather die. The impetuous Grattan became angrier by the minute. Soon, his patience was exhausted. He ordered his men to fire. Conquering Bear was wounded in three places. Young Curly saw it happen. He never forgot it. The incident affected him profoundly for the rest of his life.

Hundreds of enraged Lakota swarmed upon the soldiers. In the melee, they wiped out Grattan and his entire command.

That day, the combination of a worthless cow, an angry emigrant, an intractable Minneconjou, and an unseasoned officer set off the bloody Indian wars that would continue for over twenty years.

North Platte River at Grattan Massacre site, east of Fort Laramie, Wyoming

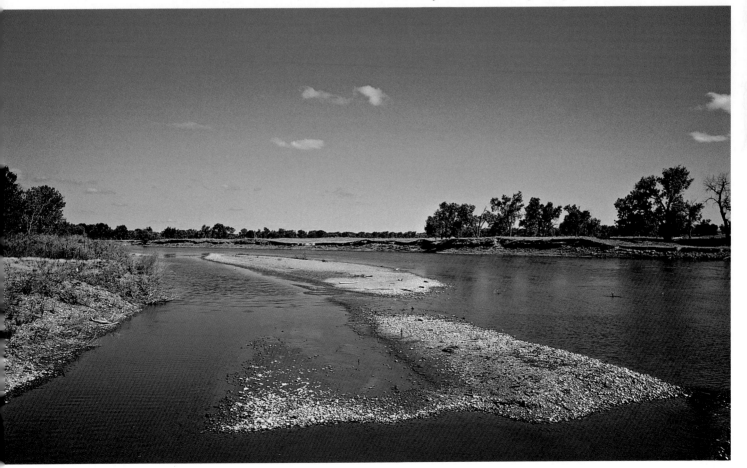

September 1854

Fearing retaliation after the Grattan Massacre, the Oglala and Brulé left the area immediately, traveling north to the Running Water River in the Sand Hills. It would be a good place for Conquering Bear, who was severely wounded, to recover.

Now age thirteen, Curly was old enough to know that whites could not be trusted, even if he did not fully understand why. He could not comprehend why the soldiers had fired on his people—especially after Conquering Bear had tried to remedy the unfortunate incident.

Niobrara River, south of Rushville, Nebraska

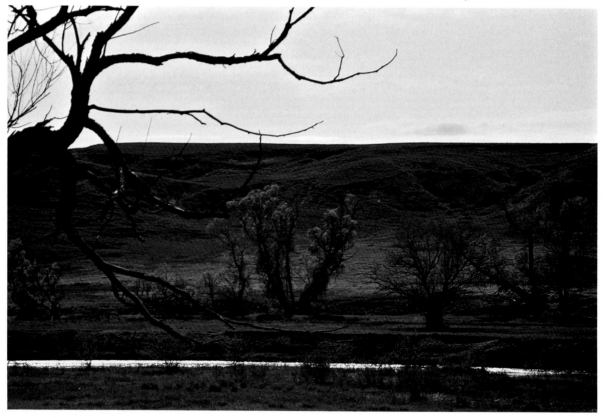

September 1854

As Conquering Bear's condition worsened, Curly, naturally shy and quiet, withdrew even more. One day he took his pony and went off to seek a vision. Perhaps he would also find answers to the many questions in his troubled mind.

Curly climbed a low bluff along the Running Water River and lay down on the rough earth. For three days he stayed there without food or water, but no vision or enlightenment came.

Disheartened and discouraged, Curly came down from the hill. His quest had been fruitless. At the bottom of the bluff, near his tethered pony, he sat down to rest from his exhausting ordeal. Soon he fell into a deep sleep and had a strange dream.

He woke to a hand shaking his shoulder. Above him, his father and Hump, a great warrior and Curly's long-time teacher and mentor, stood glowering. They were angry with the boy for going off by himself in an area full of roving Pawnee and Crow.

Curly said nothing about his dream.

A few days later, Conquering Bear died. On a small hill overlooking the Running Water River, his people laid his body on a scaffold.

Cottonwood trees near Merriman, Nebraska

November 1854

The mourning time for Conquering Bear was past. Already, great flocks of geese, ducks, and cranes were flying south. It was time to lay up a supply of buffalo meat for the approaching winter.

Hump had schooled Curly well in the skills of a hunter and warrior. The boy was adept at making arrows, tracking, and bringing down birds and small game. Sensing that Curly was ready, Hump invited him to participate in the hunt for the buffalo. This was especially fitting since it had been Curly who, ear to the ground, first heard the trembling that signaled the buffalo were near.

On the hunt, Curly immediately got a calf with one shot of his bow, but it took four arrows to bring down his second buffalo.

That night around the campfire, Hump proudly told the deeds and sang the praises of the brave, apt pupil he had come to love like a little brother.

Buffalo

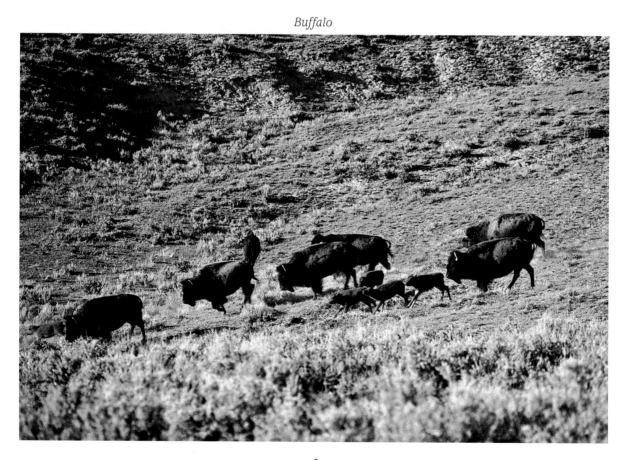

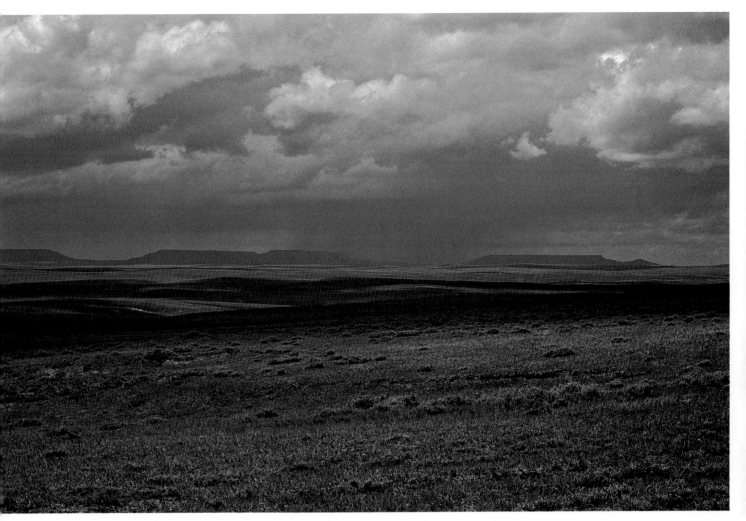

Pumpkin Buttes, Wyoming

Winter 1854–Spring 1855

In the months after the Grattan Massacre, the army did not mount a campaign against the Lakota, but the Indians made a few raids against whites to avenge the killing of Conquering Bear. Spotted Tail, Curly's uncle (his mother and stepmother's brother), led one of the raids. His band robbed and burned a mail coach carrying twenty thousand dollars and killed three men.

Although the army had a few skirmishes with the Indians, it was not actively engaged in quashing them. But military commanders were working on a plan that they hoped would bring the Indians under control.

June 1855

Warring with enemies was a regular summer activity for Plains Indians. In one raid led by Spotted Tail, the Lakota and the Omaha clashed at Beaver Creek.

It was Curly's first real battle. During the heavy fighting, Omaha chief Logan Fontenelle was killed. Curly's arrows sailed straight and true. One found its mark in an Omaha crawling through the bushes.

When Curly turned the body over to take the scalp, he saw that he had killed a young woman, not a warrior. The dead girl at his feet bore a striking resemblance to his sister, Laughing One. Repulsed by what he had done, Curly could not take the scalp. Later, he endured the good-natured jeers of his comrades for failing to take such an easy prize.

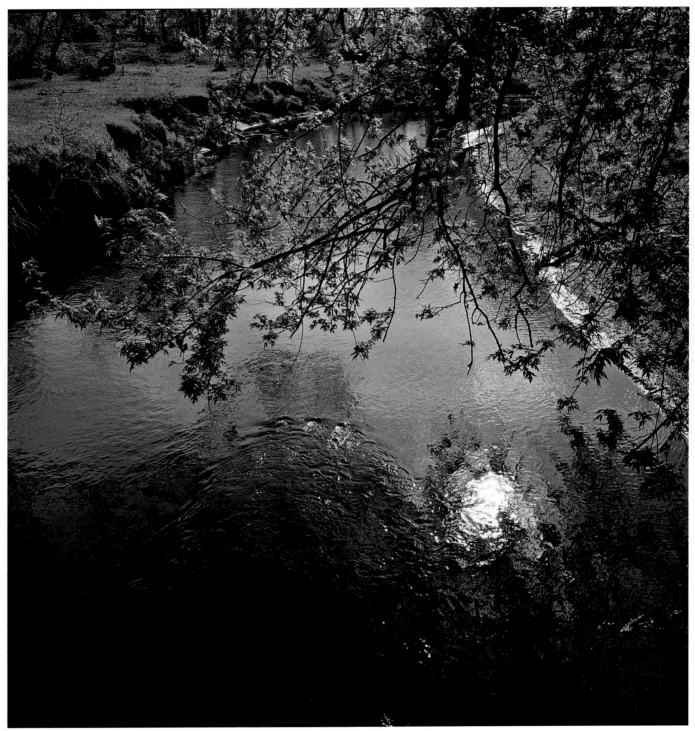

Beaver Creek, Boone County, Nebraska

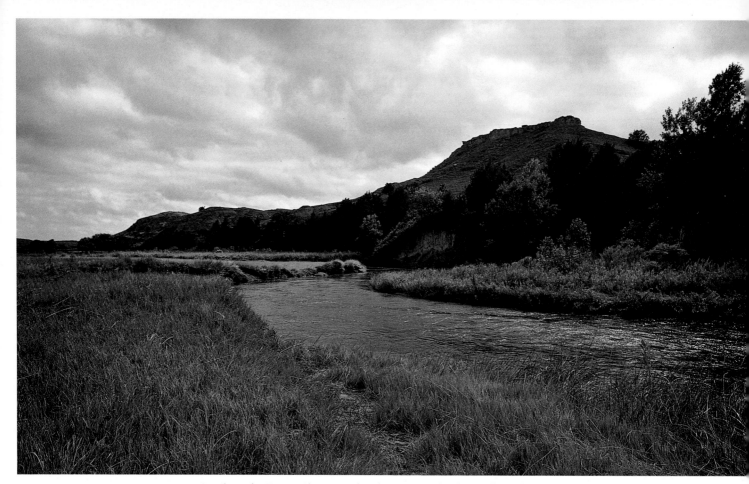

Rattlesnake Butte, Bluewater battle site, north of Lewellen, Nebraska

July–August 1855

Thomas S. Twiss was appointed the Indian agent of the Upper Platte region. To determine which Indians were friendly, Twiss ordered all of them to come and stay south of the North Platte River. There, he promised, they would be protected and would receive the goods guaranteed by the 1851 treaty. Indians who stayed north of the Platte would be considered hostiles, and troops would be sent against them.

The Brulé chief Little Thunder was camping with his people on the Bluewater River, north of the Platte. It was well known that Little Thunder was peaceful and friendly toward the whites. He assumed the order did not apply to him.

September 1, 1855

Troops under the command of Brigadier General William S. Harney set out to look for any Indians who had disobeyed Twiss's ultimatum.

September 3, 1855

Harney approached the Bluewater camp from the south. Under a white flag, Little Thunder, Spotted Tail, and two other warriors rode out to meet him. Harney halted to talk with them, but his infantry continued to advance. Harney told Little Thunder and the others that they had better return to camp and prepare to defend themselves; he had come to fight.

Shocked and dismayed, the Brulé raced back and told their people to run. But, unbeknownst to them, Harney's cavalry was approaching from the north. The fleeing people ran headlong into their charge.

The surprise of the attack resulted in terrible Indian losses. The soldiers killed eighty-six of the two hundred and fifty people in camp and captured seventy. Most of the dead were women and children; Harney's men had mowed down any Indians who could not get away.

At the time of the massacre, Curly was visiting relatives in Little Thunder's camp. Off hunting with friends when Harney attacked, the boy heard gunfire and saw an unusual amount of smoke rising from camp. Something was wrong. He crept to the top of a butte to look down into camp. The destruction and carnage he saw physically sickened him. No Lakota had ever seen such a sight; their camps had never been attacked by soldiers in force before.

Curly set out on one of the trails made by the escaping Indians. Soon he stumbled across a dead boy. While staring at the body, he heard faint whimpering coming from a pile of buffalo robes beside it. He threw back the robes to find a young woman cowering with a newborn baby. She identified herself as Yellow Woman, a Cheyenne. Like Curly, she had been visiting in the Brulé camp. Curly helped her up and together they made their way north to rejoin Little Thunder. As they traveled, Yellow Woman recounted what had happened.

1855–1856

After the Bluewater battle, Curly and his family moved to the White Earth River along with other Lakota. The fight had been taken out of them. Now they knew what the soldiers were capable of if they were disobeyed.

Harney sent word to the Indians that the men involved in the mail coach killings and robbery must come in for punishment. When they did, the captives taken at the Bluewater battle—one of whom was Spotted Tail's daughter—would be released. Obeying the order, the entire Brulé camp moved to Fort Laramie.

Spotted Tail and the other raiders gave themselves up. They were incarcerated at Fort Leavenworth. Yet the captives were not released. Only after Spotted Tail's sentence ended in the autumn of 1856 were they finally freed.

A changed Spotted Tail rejoined the Lakota. At Fort Leavenworth he had been treated well, and had been exposed to the white man's world. The many soldiers in the U.S. army and the amount of firepower at their disposal had made a mighty impression.

In his uncle's lodge, Curly listened to Spotted Tail tell his kinsmen it was useless to fight against such odds. They could never win; it was best to be peaceful. Curly wondered how such words could come from a great warrior's mouth.

White Earth River, west of Crawford, Nebraska

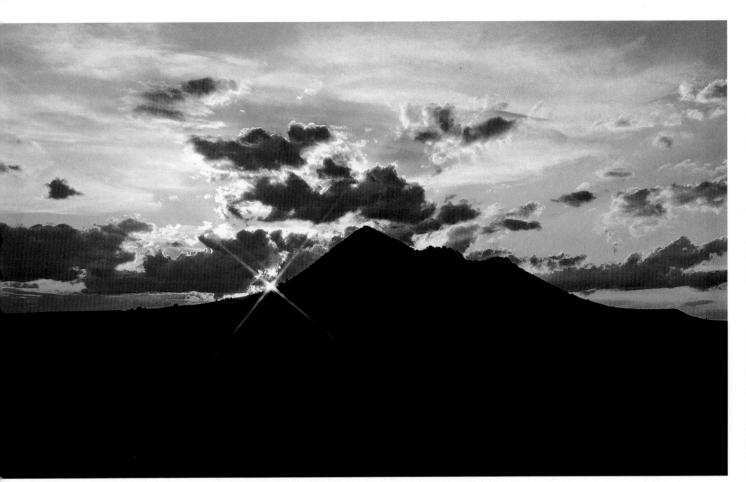

Bear Butte State Park, east of Sturgis, South Dakota

Summer 1857

The Cheyenne and Lakota had always been allies, but Curly and Yellow Woman had developed a great fondness for each other. After a lengthy visit with Yellow Woman's people in the spring, Curly rode to sacred Bear Butte, where his people's council was taking place again.

It was a huge gathering. All seven of the Teton Sioux camps were represented. For the first time, Curly met many of his people's distinguished chiefs. Sitting Bull of the Hunkpapa was there. So was Red Cloud, of the Bad Faces, one of the seven bands of the Oglala.

Curly was particularly attracted to Red Cloud's comely niece, Black Buffalo Woman. Black Buffalo Woman seemed just as interested in the handsome Oglala with the hazel eyes and aquiline nose.

Curly also became acquainted with Touch-the-Clouds, the towering seven-foot Minneconjou warrior who was his cousin. Touch-the-Clouds would become a close friend.

During the council, the Indians agreed not to allow whites to cross the boundaries of their lands—boundaries defined in the 1851 treaty.

September 1857

On their own, Curly and his father made their way home from the council, relaxed and companionable as they traveled. One evening, they made camp at Rapid Creek—the place where, fifteen years earlier, Curly had been born.

Curly had often wished to tell Crazy Horse, his father, about the strange dream he had had back in the Sand Hills, but the time had never seemed right. Now, in the place where he was born, alone with his father—a holy man and interpreter of dreams—the time had come.

His father smoked and listened as Curly related the dream, as fresh in his mind as if it had happened yesterday.

In the dream, a man appeared dressed in a white buckskin shirt and blue leggings, with a single eagle feather in his long brown hair. Unadorned with paint, he had a small brown stone tied behind his ear. He was astride a horse that had risen from a lake and seemed to float in the air. The horse changed colors many times as it floated through a strange place that seemed not of the earth and yet was. Enemies fired arrows and bullets at the horseman, but he rode through them unscathed. Several times, Lakota restrained him, holding him back from going ahead. Then he rode out of a thunderstorm wearing only a breechcloth. He had painted a zigzag streak shaped like lightning on his cheek and white spots like hail on his body. The horseman did not speak, yet he communicated to Curly that he was never to wear a warbonnet; that he should rub his horse and himself with gopher dust before every battle to prevent bullets from striking him and enemies from killing him; and that he should never take anything for himself.

Curly's father reflected for some time. Then he told his son that his dream was a great vision. He would be a leader of his people and ride in front of the warriors. This would not endanger him, because his enemies' bullets and arrows could not hurt him. If any harm came to him, it would be because he was held by one of his own people.

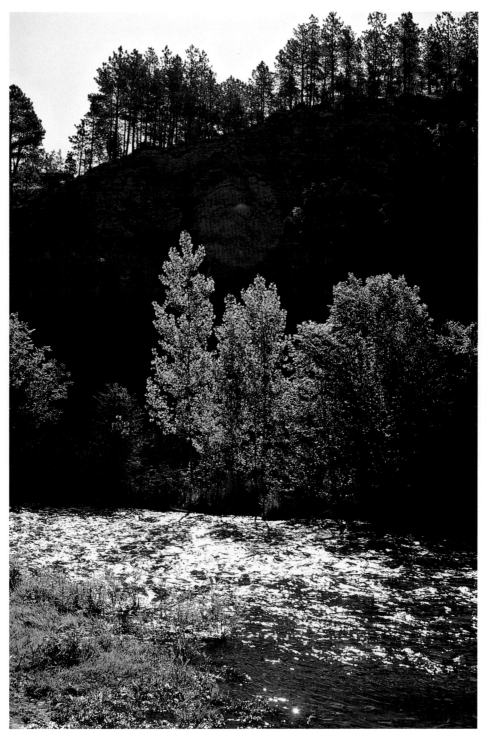

Rapid Creek, near Rapid City, South Dakota

Summer 1858

When Curly was fifteen, an Oglala in his own camp accidentally wounded him in the knee. This led some to believe that Curly's vision was prophetic. Another incident dispelled any doubt.

A small war party including Hump, Little Hawk, and Curly rode far away to the west, to the Wind River, to fight the Arapahoe. In the thick of battle, bullets and arrows flew close around Curly, but he was never hit.

Curly succeeded in killing two Arapahoe. In his excitement, he jumped from his horse and took their scalps. Remounting, he was hit by an arrow in the leg. Immediately, he cast the trophies away, remembering that the horseman in his vision had told Curly never to take anything for himself. The boy had violated this dictum; his wound was the punishment. The wound was not serious, but it convinced Curly that he must abide by what he had learned in his vision. As long as he did, he believed, his medicine, or luck, would be good.

Wind River, northwest of Riverton, Wyoming

Summer 1858

The Arapahoe battle was a victory for the Lakota; they captured many horses and lost no men. In the camp circle that night, as was their custom, the warriors recounted their deeds and were lauded. Curly could have boasted of his exploits but said nothing. That was his way. But others who had been in the battle praised him as a brave warrior.

The next day, Curly's father, Crazy Horse, sang throughout the village of his son with the powerful medicine. His song told of his bravery and of the new name with which he was honoring him—the name of many of his grandfathers and of himself: Crazy Horse.

On that day, Curly the boy ceased to exist. Crazy Horse the Oglala warrior took his place.

Vicinity of Riverton, Wyoming

Every summer, the Lakota fought the Crow, but it was more sport than all-out war. Usually if too many warriors were killed, one side or the other withdrew. No tribe wanted to lose valuable manpower.

When Indians fought other Indians, rather than killing an enemy, it was considered more brave to ride into battle, exposing oneself to danger, and merely touch the enemy. This was called counting coup. A warrior counted coup with his hand, a weapon, or a coup stick—a special stick for that sole purpose. To be brave—even to die—in battle was a great honor. Warriors threw themselves heart and soul into a fight.

Sometimes warriors raided enemy pony herds at night, but they seldom fought battles in the dark, or in the winter months. The Lakota preferred their snug lodges to fighting in the cold and snow.

These customs changed when the Lakota began fighting the U.S. army. The soldiers struck at any time, in any season. The Lakota did not want to fight the army. They enjoyed and depended on trade goods from the whites such as tobacco, sugar, clothing, and, most important, guns and ammunition. But the whites encroached on Indian lands. Soldiers attacked Indian villages, killing many who could not defend themselves—women, children, and old people. The Indians were driven to retaliate, and the fighting began in earnest.

Although the Lakota were good guerrilla fighters, they lost many battles with the army because they did not fight as one cohesive unit under a leader directing offensive and defensive actions. One chief or warrior might lead others into battle, but he did not issue orders the way army officers did. Instead, each warrior fought individually, as he pleased, on the battlefield.

One Indian tactic fooled the soldiers time after time. In full view, a few warriors would act as decoys, either luring soldiers from a protected place or drawing a whole troop toward the main body of warriors who were lying in wait.

Another, less effective tactic was the surround. Warriors rode their ponies into a circle around the enemy. Now and then, one would break from the moving circle to count coup on a soldier inside. When the Indians tired of the "game"—or their losses were many—they simply rode away.

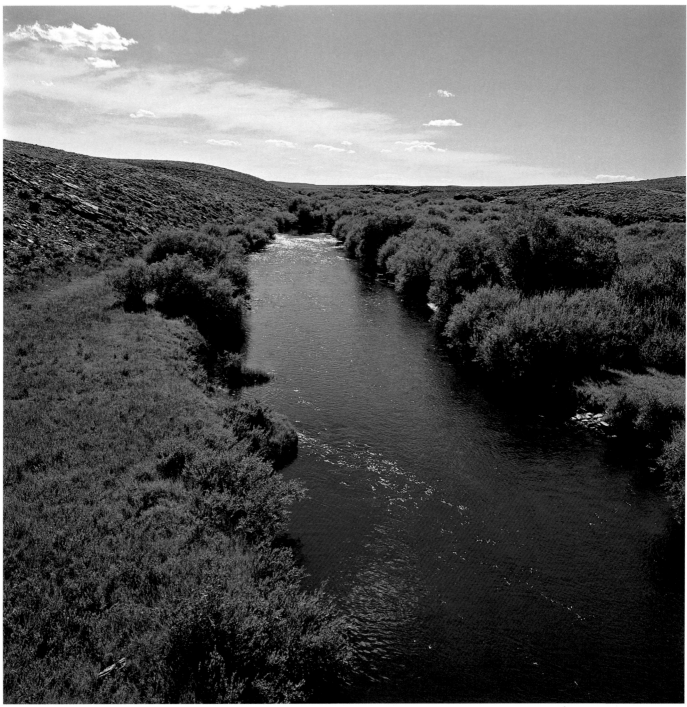

Sweetwater River, south of Lander, Wyoming

TWO

Crazy Horse Falls in Love

June 1861

Crazy Horse was again visiting the Cheyenne when runners arrived in camp. They brought word that the Oglala were on their way to fight the Snake. Crazy Horse decided to join his people. Some Cheyenne warriors accompanied him.

The warriors attacked the village of Washakie, chief of the Snake, on the Sweetwater River. Crazy Horse fought in his usual style, jumping from his horse before he shot for more accurate aim.

In the long fight, Crazy Horse distinguished himself again by his bravery. He and other warriors counted many coups; the Oglala captured four hundred horses; and Washakie's son was killed. The Oglala said he died well—a compliment they paid anyone, friend or enemy, who was a brave warrior.

Summer 1862

Crazy Horse often visited Red Cloud's camp. This gave him the opportunity to see Black Buffalo Woman. At age nineteen, it was time to take a wife. Many evenings, Crazy Horse waited with other suitors outside Black Buffalo Woman's tipi for the time—always too short—he was allowed to spend with her.

Crazy Horse intended to marry Black Buffalo Woman. But, despite his growing fame as a warrior, Crazy Horse came from an ordinary family that wielded little power in tribal politics. For his niece, Red Cloud wanted someone more important, someone who could help elevate his own position—someone like No Water, whose older brother, Black Twin, had long served on the tribal council.

At this time, Red Cloud was forming a war party against the Crow. To fight alongside the great warrior Red Cloud would be good medicine; Crazy Horse and the other warriors in camp joined the party. After riding out a short distance, No Water, complaining of a toothache, returned to the camp.

After the raid, Crazy Horse returned to find that No Water had married Black Buffalo Woman. Distraught and angry, Crazy Horse stayed in his lodge for three days, then went off alone, telling no one where he was going or when he would return.

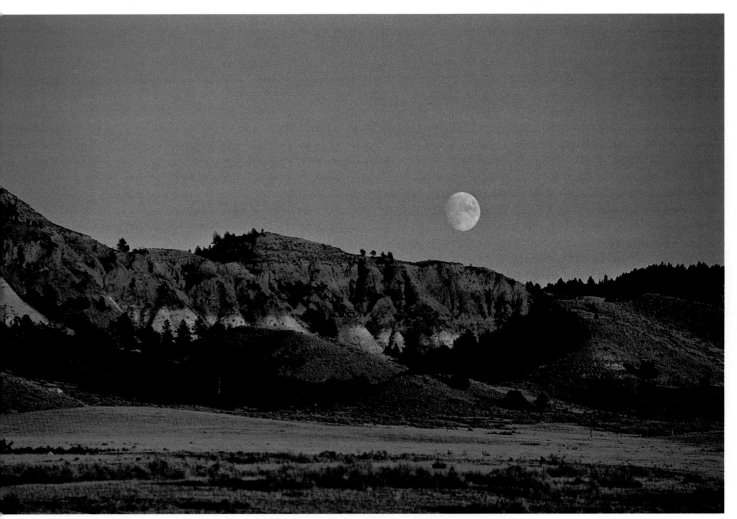

Buttes, south of Broadus, Montana

Winter 1862–1863

Crazy Horse and many of his people spent the winter of 1862–1863 on the Belle Fourche River. As always, they camped in a spot sheltered from the north winds, with plentiful supplies of water and cottonwood trees. The people used the trees for fuel, and when the grass was gone or covered by deep snow, their ponies ate the cottonwood bark.

Devils Tower National Monument, Wyoming

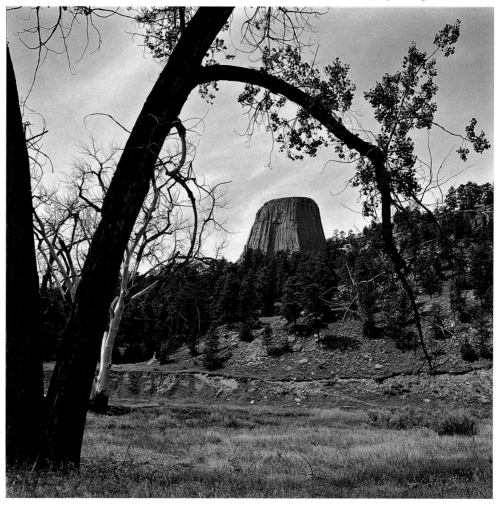

34

Belle Fourche River, near Devils Tower, Wyoming

Summer 1863

By 1861, telegraph lines to the Pacific Coast had been completed. Branch telegraph stations were located at intervals along the route.

Intrigued by the white man's singing wires, Crazy Horse struck up a friendship with the telegraph operator at Deer Creek, where Indian agent Thomas Twiss had also set up an agency.

The operator, Mr. Collister, introduced Crazy Horse to Lieutenant Caspar Collins, who was stationed at the small garrison nearby. Soon Collins and Crazy Horse were hunting buffalo together on the vast sagebrush plains. That winter, Collins visited Crazy Horse's camp often to learn the Lakota language and ways.

Buffalo skull

Near Lake De Smet, Johnson County, Wyoming

Summer 1863

After gold was discovered in the Montana Territory, John Bozeman staked out a trail to the gold fields. Branching off from the Oregon Trail, it ran directly through the heart of Lakota hunting grounds east of the Big Horn Mountains. To the Lakota, already distressed by the number of people invading their land on the Oregon Trail, this was yet another encroachment and violation of the 1851 treaty.

When Bozeman tried to escort the first wagon train over the trail, Crazy Horse was among the Lakota under Red Cloud who gathered in a great semicircle on the bluffs ahead of the train. Standing stolid and mute, the mounted warriors would not let the whites proceed onto their lands. Rotating with each other, they maintained this position for a week, always leaving the bottom of the circle open to the south so the whites could go back where they belonged.

Word of the wagon train's predicament reached the commanding officer at Fort Laramie. He sent a detachment of soldiers to escort it back. No hostilities ensued, but the confrontation showed the Indians' determination to keep their lands inviolable.

Fort Laramie National Historic Site, Fort Laramie, Wyoming

❧ THREE ❧
The War of 1864–1865

Summer 1864

Relations between whites and Indians deteriorated. Army officers issued various orders that the Indians could not or would not obey. Officers rarely considered the Indians' situation or point of view, and for the most part, dealt arrogantly with them. They considered them savages with little intelligence, who were easy to deceive and control with the might of the army.

The Indians made persistent raids on the emigrant trails and small settlements. One day, probably out of sheer exasperation with the state of things, Crazy Horse led a small party of Lakota through Fort Laramie. Intending only to stampede some horses grazing on the parade ground, suddenly he and his band were through the fort, driving the horses before them and speeding away to the north.

As was his practice, Crazy Horse distributed the captured horses among those in his camp who needed them.

Near Julesburg, Colorado

February 2, 1865

On November 29, 1864, another massacre led by Colonel John M. Chivington took place at a Cheyenne village far to the south on Sand Creek. An especially arrogant man, Chivington never concealed his hatred of Indians. Yellow Woman and other friends of Crazy Horse were killed in the raid.

Indian retaliation began immediately. Cheyenne and Lakota, sometimes banding together, raided white settlements with a vengeance.

In February, Crazy Horse was one of a thousand warriors involved in the largest attack yet on the whites. They targeted the garrison and warehouse on the open plain at Julesburg. Despite the Indians' great number, the soldiers, wisely holed up in their stockade, lost only eighteen men. Annoyed by the whites' refusal to come out and fight, the Indians swept through the settlement, pulling down telegraph wires and looting the warehouse before riding away.

June 14, 1865

Crazy Horse's uncle Spotted Tail wanted peace with the whites. He wanted it so much that he and Little Thunder moved south with sixty other lodges to Fort Laramie. They intended to join the community of Indians who lived there and were known as "The Friendlies."

The new military commander Major General Grenville M. Dodge was ignorant of Lakota ways and intentions and considered all Indians hostiles. He ordered the entire Indian community at Fort Laramie—some two thousand Indians with one hundred eighy-five lodges—removed under guard to Fort Kearny, about three hundred miles to the east.

Spotted Tail was understandably bitter. In addition to their unexpectedly inhospitable reception, his people were treated cruelly by the soldiers on the march. Among other insults and depredations, children were beaten and women were raped. Spotted Tail sent word to Crazy Horse and other warriors to come help the Lakota escape.

Crazy Horse and the warriors found the captives camped at Horse Creek. That night, they placed stakes in the North Platte River to mark a crossing. Before dawn, Spotted Tail and his people hurried across the Platte, leaving their lodges and most of their belongings behind. Their friends waited on the other side with horses. Soon the freed Lakota were making their way north, guarded by the warrior contingent.

North Platte River, near Horse Creek, Nebraska

41

Early July 1865

After the escape at Horse Creek, the Lakota and the Cheyenne people held a great council and sun dance on the Powder River. There, leaders from both tribes prepared a large expedition against the whites. Elaborate ceremony surrounded the preparations to an extent not seen in years.

When the ceremonies were over, each warrior attended to his own personal medicine. As was his custom, Crazy Horse painted lightning streaks on his face and hailstones on his body, and sprinkled gopher dust on himself and his horse. Then, three thousand Lakota and Cheyenne warriors set off to the south.

Powder River near Broadus, Montana

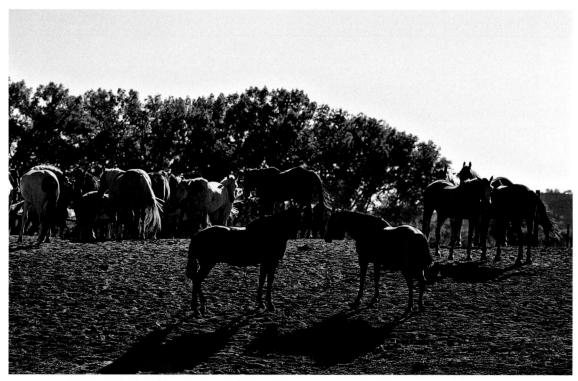

Horses

July 25, 1865

The combined Cheyenne and Lakota forces descended on a small garrison at Platte Bridge on the Oregon Trail. With other warriors, Crazy Horse acted as a decoy to lure the soldiers out. A small detachment of soldiers appeared, but the impetuous warriors broke from their hiding places before the soldiers were close enough to fire on. Realizing the trick, the soldiers withdrew to the stockade, cheating the Indians of a fight. Furious, the Cheyenne and Lakota turned their attention to some horses pastured across the river and to cavalrymen coming along the trail. They stampeded the horses and engaged the cavalry in a short skirmish, then withdrew. The next day, having tipped their hand, the Indians found the soldiers prepared for another attack.

Lieutenant Caspar Collins happened to be leading a troop across the bridge at the garrison. Unaware that Collins was a friend, Cheyenne warriors waited behind a ridge to attack. Red Cloud tried to warn Collins, without success. Breasting the ridge, Collins and several of his troop were killed.

The death of his friend deeply distressed Crazy Horse.

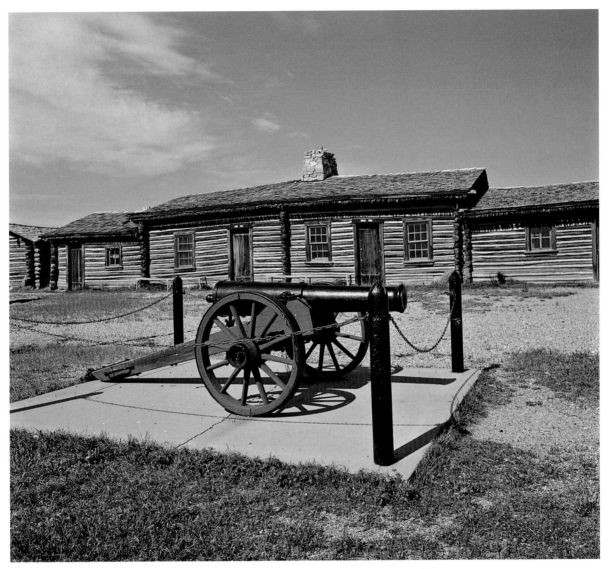
Fort Caspar State Historic Site, Casper, Wyoming

August 1865

General P. C. Connor, Colonel Nelson Cole, and Colonel Samuel Walker commanded three columns of troops sent north to punish the Indians scattered in camps along the Tongue, the Powder, and the Little Missouri Rivers. The three commanders were inept and their troops—many of them easterners transferred west to serve out their Civil War enlistments—had no appetite for fighting Indians. The columns moved aimlessly about, engaging a few Indians now and then. The Indians dogged and harassed the soldiers in return.

After the Cole and Walker columns met and joined together, Crazy Horse and his band tracked them up the Powder River, eventually stealing eighty horses.

September 2–8, 1865

During the army's ill-conceived and badly executed campaign, the weather was unseasonably cold. Hundreds of the army's horses and mules froze to death in ice storms. With no draft animals to carry stores and pull wagons, the miserable soldiers burned supplies or left them on the ground as they hurried from the unfriendly country. The Indians gathered many abandoned guns and much ammunition. Crazy Horse became the owner of a fine breech-loading rifle.

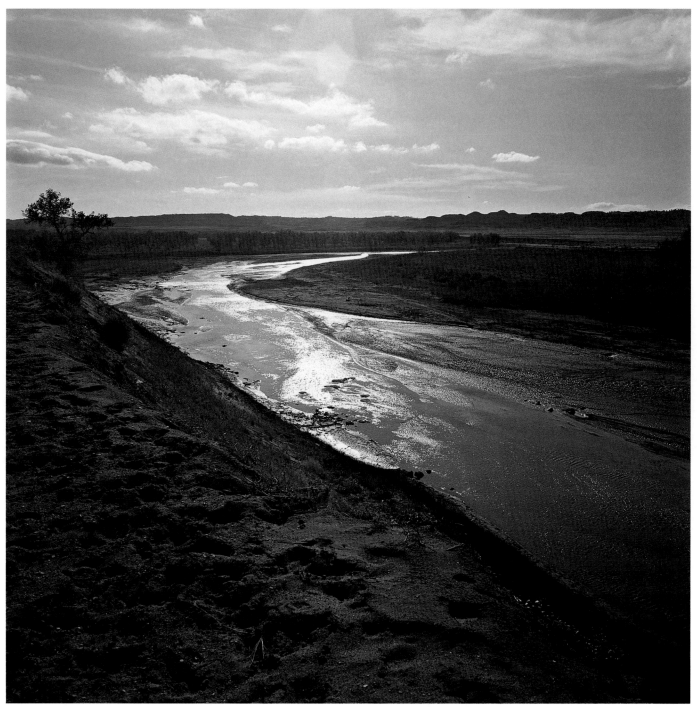

Powder River, south of Terry, Montana

Mouth of the Little Powder River, near Broadus, Montana

Late September 1865

At a ceremony at the mouth of the Little Powder River, the warriors Crazy Horse, Young-Man-Afraid-of-His-Horses, American Horse, and Sword were made shirt-wearers because of their bravery and leadership.

Shirt-wearers were in charge of the warriors at all times. They maintained order and safeguarded the rights of tribal members. The shirt they were entitled to wear was a lavishly decorated garment made from the skin of a bighorn sheep.

The designation was a special honor for Crazy Horse, a commoner. Rarely was anyone other than a chief's son chosen to wear the shirt.

At the ceremony, Crazy Horse was singled out and praised for his concern for others. A generous man, he always gave to the needy the goods and horses he obtained on raids.

❧ FOUR ❧

The Bozeman Trail

Spring 1866

Red Cloud and other Lakota leaders were asked to come to Fort Laramie to a peace council. The whites hoped to persuade the Indians to open the Bozeman Trail. For two years, the Indians had allowed no one but a few miners to use the road.

During negotiations, a Brulé happened to chat with Colonel Henry B. Carrington, who had just arrived. Carrington admitted that he was on his way into the Powder River country to oversee the building of forts along the Bozeman Trail.

When the other Indians heard this, they realized they were being deceived again. They left Fort Laramie vowing to fight any whites who ventured into their territory. If the peace council had achieved anything, it was not peace.

July 1866

From a ridge, a rancorous Crazy Horse watched the building of the first fort on the Bozeman Trail—Fort Phil Kearny, at the eastern foot of the Big Horn Mountains.

Fort Phil Kearny State Historic Site, south of Story, Wyoming

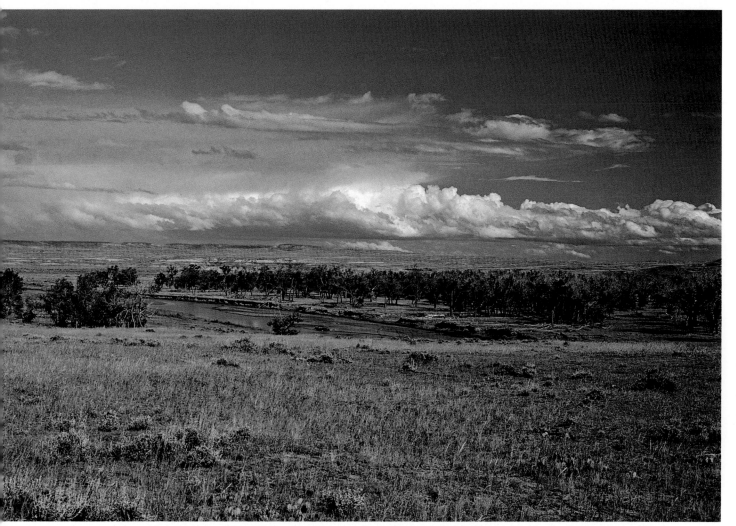

Site of Fort Reno, northeast of Kaycee, Wyoming

July 1866

Crazy Horse, Hump, and Young-Man-Afraid-of-His-Horses led war parties as far south as Fort Reno to attack wagon trains using the Bozeman Trail. Since the whites persisted in going where they had been warned not to, there would be no peace. So, on the raids, warriors captured all the guns and ammunition they could get their hands on.

December 21, 1866

The Indians wondered why the whites built Fort Phil Kearny where it was—several miles from a supply of wood. This made it necessary for soldiers to accompany woodcutters when they went out. But the soldier contingents did little to deter the Indians.

On a bitter cold day, Captain William J. Fetterman took a detachment of cavalry and infantry out to relieve the small detail with the woodcutters. Fetterman, who once boasted that he could ride through the entire Sioux nation with fifty men, had specific orders not to go beyond Lodge Trail Ridge to the north, where his troop would be out of sight of the fort. Fetterman was familiar with the Indians' decoy trick. Nevertheless, when Crazy Horse appeared with a small band of warriors, they succeeded in luring Fetterman away from the direction of the woodcutters.

Giving the impression that his party was small and isolated—easy prey for so many soldiers—Crazy Horse enticed Fetterman with a variety of tactics. He stayed at the rear of the decoys, pretending he could not keep up with the others. Several times he dismounted, appearing to have trouble with his horse. Once, when the soldiers lagged too far behind, he actually stopped, built a small fire, and warmed his hands over it. Playing their parts, the others shouted to him to come on. Crazy Horse indicated that he was going to surrender to the soldiers. But when they came near, he sprang to his pony and dashed after the other decoys. Fetterman's men followed in hot pursuit. The decoys led them over the crest of Lodge Trail Ridge into the valley beyond. At a signal, waiting Lakota sprang from the brush.

In the furious fighting, all the infantrymen who had straggled behind were killed. Warriors drove the cavalry to the crest of a hill and surrounded the base of it. In minutes, all the soldiers were wiped out except for Fetterman and Captain Frederick H. Brown, who took cover together behind some low rocks. Knowing they were doomed, they fired all but the last bullets in their revolvers. Then, as the Indians advanced, they shot each other.

After the fight, Crazy Horse searched for Lone Bear, a childhood friend. He had lost sight of him when the battle began. It was dusk before he found Lone Bear, partially frozen, behind a bush. His friend was still alive but mortally wounded. As Crazy Horse lifted him into his arms, Lone Bear opened his eyes and managed a weak smile before he died. Tears flooded Crazy Horse's eyes as he held his long-time companion, now cold and lifeless.

Fetterman Massacre Site, Story, Wyoming

January 1867

Buffalo were scarce in the Powder River country, yet much meat was needed to supply the large camp that had been assembled to keep up harassment on the three Bozeman Trail forts: Fort Phil Kearny, Fort Reno, and Fort C. F. Smith.

Hunting parties went out constantly, usually without success. But far from camp, at Crazy Woman Creek, Crazy Horse and his brother Little Hawk managed to kill eight elk. They distributed the meat among the hungry people. As usual, Crazy Horse took none for himself.

Near the mouth of Crazy Woman Creek, Johnson County, Wyoming

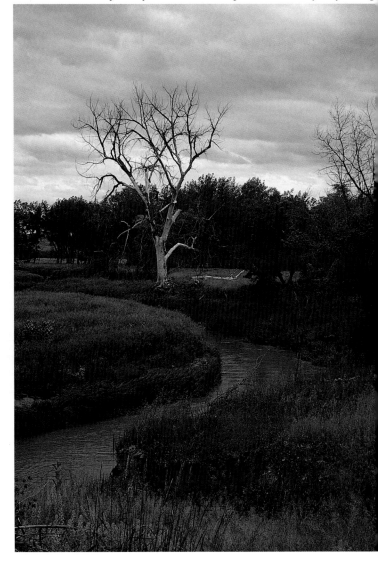

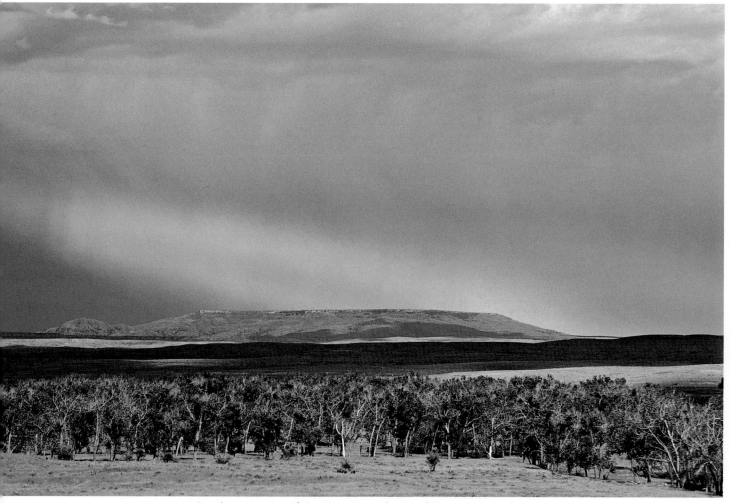

Sundog over site of Fort Reno, northeast of Kaycee, Wyoming

Early Spring 1867

When Crazy Horse and his brother were not hunting, they often rode to Fort Reno to drive off soldiers' horses and harass the garrison. For the time being, they left Fort Phil Kearny in peace.

July 1867

The whites still hoped for a peace treaty that would end the troubles on the Bozeman Trail. They sent word to the Indians that they wanted to meet again.

At a council on the Powder River, Indian leaders selected Old-Man-Afraid-of-His-Horses, an elder chief of the Oglala, to go to Fort Laramie. Red Cloud would also go to represent the warriors and to make sure that Old-Man-Afraid would not agree to anything but the Indians' terms. These were: no treaty would be signed unless the whites abandoned the forts along the Bozeman Trail and gave the Indians a good supply of ammunition.

At Fort Laramie, the whites would not accept the Indians' terms. Old-Man-Afraid and Red Cloud, angered, abruptly left the fort.

August 2, 1867

Since the whites were not cooperating, Red Cloud and Crazy Horse planned another attack on Fort Phil Kearny. They knew that attacking the fort directly was not likely to succeed, so they planned an assault on a small outpost that Captain N. J. Powell had set up near the wood-cutters' camp.

As a defensive measure, the captain had ordered the wheels taken off some wagons and the wagon boxes arranged in a circle. Inside the circle were tents and a space for horses and mules.

Powell knew that if Fetterman had not run out of ammunition, he and his soldiers might have survived. He had an abundance of ammunition with him.

With Hump, Crazy Horse again led a decoy party close to the woodcutters, hoping to draw the soldiers out from their enclosure. But before the soldiers could venture from behind the wagon boxes, over-eager warriors swarmed from their hiding places.

Still, Crazy Horse managed to organize them. Circling the wagon boxes, the warriors fired arrows into them until they resembled pincushions.

Powell's men, armed with breech-loading Springfield rifles, kept up a steady rain of bullets. Short of ammunition, the Indians retreated to a ravine. Next, Crazy Horse led an assault on foot. Again the warriors were unsuccessful. As they withdrew, Crazy Horse realized they would need more guns and ammunition to fight the whites effectively.

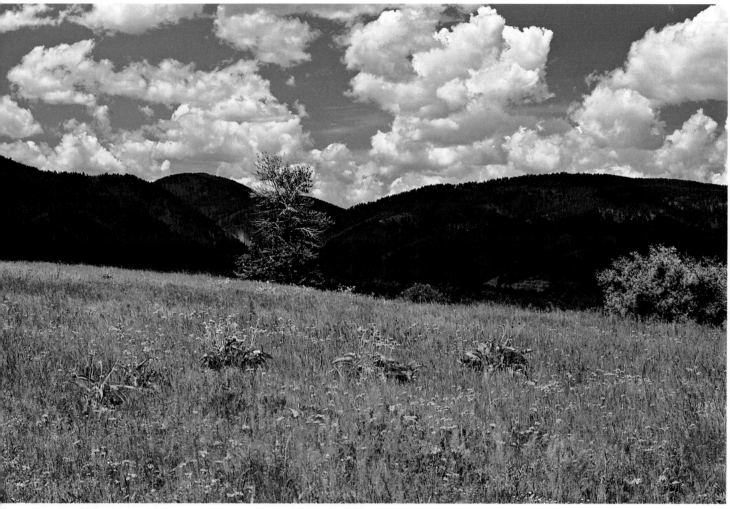

Wagon Box Fight site, Story, Wyoming

March 19, 1868

Spring found Crazy Horse back on the North Platte River engaging in small raids on whites. With him, among others, were his brother and Little Big Man, an old friend.

During one raid, Crazy Horse and about seventy Lakota came upon the Horseshoe Ranch stagecoach station. Immediately, they were fired on. Two Lakota were killed and several others wounded. The warriors set fire to the buildings. Unbeknownst to them, the station personnel escaped through a tunnel to a ranch building at nearby Twin Springs. They hid belongings and supplies they had taken with them, and burned the building, so the Indians would not suspect that valuables were left there. Then, on horses corralled at the ranch, they headed for Fort Laramie.

Tracking them easily, Crazy Horse's band caught up with the escapees and fired on them. The whites fought back fiercely. Soon all but four of them had been killed. When these were surrounded, Crazy Horse said there had been enough fighting. He made the sign for peace and approached the exhausted, bedraggled whites. Lighting his pipe, he offered it to them; they accepted it. They told him about the goods they had hidden and said he could have them if he let them go. The whites did not cower or show fear. Impressed by their determination and bravery, Crazy Horse agreed to their proposal.

Twin Springs near Glendo, Wyoming

❧ FIVE ❧
The Treaty of 1868

July 1868

For a year now, a stalemate had existed between the Indians and the U.S. government. The Indians would sign no treaty until the whites abandoned the forts along the Bozeman Trail.

The delay in signing annoyed the government, and the army was weary of the constant fighting in the Powder River country. In addition, for construction of the Union Pacific Railroad to proceed unhindered, the government needed the Indians to stay in their own territory. Reluctantly, the whites concluded the time had come to accede to Indian terms. It was the only way to achieve what they wanted: peace with—and from—the Indians.

An order went out to abandon the forts.

Site of Fort C. F. Smith, southwest of Hardin, Montana

July 29, 1868

 With great delight, after the soldiers left Fort
C. F. Smith, Crazy Horse, Red Cloud, and other
warriors burned it to the ground.

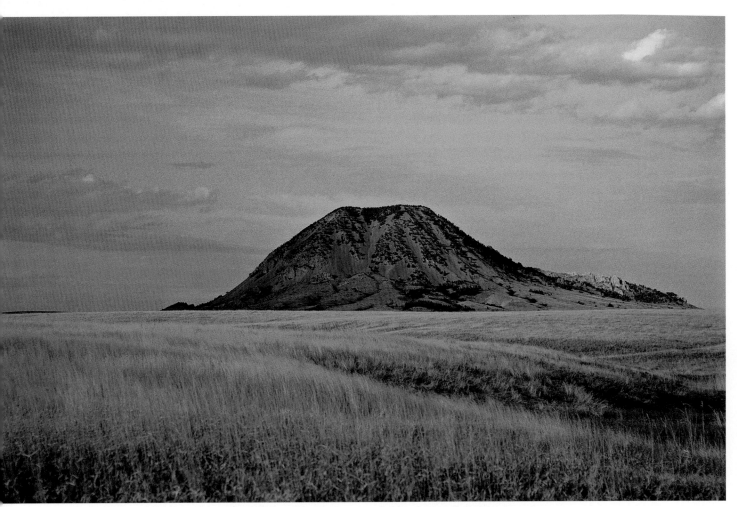
Bear Butte State Park, east of Sturgis, South Dakota

October 1868

Whites could not seem to comprehend that no single Indian was entitled to speak for a tribe—not even if he was a great chief. Few whites understood that a chief's duties were mainly ceremonial.

Recognizing this, at the council at Bear Butte, the Indians decided to designate a spokesperson and empower him to sign treaties on their behalf. Red Cloud was appointed and given the title of treaty-chief.

November 1868

Now that the Bozeman Trail forts had been abandoned, Red Cloud signed the government's treaty, but he did not fully understand its ramifications. Government officials deliberately avoided explaining the provisions for the establishment of the reservation system.

Summer 1869

Now that Red Cloud had signed the treaty, most Lakota went about their lives as they had before the troubles with whites began, still looking forward to at least one raid on the Crow each summer.

Crazy Horse and his friend He Dog organized a large war party and set off toward the Big Horn Mountains looking for Crow. They found them on Soap Creek near the Big Horn River. Crazy Horse led an assault and drove the Crow back to their camp, and a week of fighting and harassment followed. Afterwards, the Oglala celebrated the raid as a great fight and victory.

⟹⟩◇⟨⟸

After the Treaty of 1868 was signed, Crazy Horse and the other Indians who lived in the Powder River area moved north for several years. They resumed life as it had been before the white men came. It was mostly a happy time.

Spotted Tail and many other chiefs had signed the new treaty months before Red Cloud. Like him, they were uninformed about the document's contents. They thought its purpose was simply to end the fighting. Once that happened, they assumed, things would go back to the way they had been before the hostilities. Red Cloud also expected that, with peace, the whites would reopen the trading posts along the North Platte River that had been closed for two years during the fighting.

Both Red Cloud and Spotted Tail had been told to move their people to a reservation. Red Cloud did not comply, but Spotted Tail moved his people onto the Whetstone Agency Reservation on the Missouri River. He had not forgotten what he had learned at Fort Leavenworth; he was ready to cooperate fully with the whites to avoid trouble for his people. By 1870, Spotted Tail's people had been living on the reservation for almost two years. But they were not happy there, away from their traditional home.

Eventually, both Red Cloud and Spotted Tail asked to meet with the president in Washington. Spotted Tail wanted permission to move his agency to the White River—familiar country in which his people would feel more at home. Red Cloud wanted to communicate his distress that what he thought were provisions of the 1868 treaty had not been carried out. He also wanted permission to trade at Fort Laramie and to establish an agency of his own there.

In the spring of 1870, the government arranged for both men to travel to Washington. Spotted Tail eventually got what he wanted. Red Cloud did not. He insisted that he be taken home.

On the way, at the Cooper Institute in New York City, Red Cloud made an impassioned speech to a group of Indian-cause sympathizers. His new friends rallied to his aid, making such an uproar that the government eventually gave in. Red Cloud received an agency near the North Platte River close to Fort Laramie, where he and his people remained for two years.

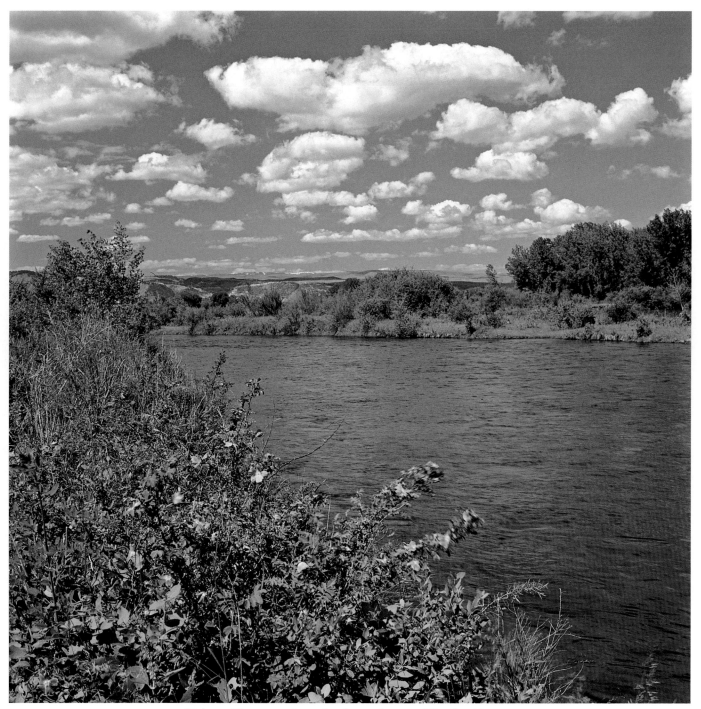

Bighorn River near Soap Creek, southwest of Hardin, Montana

Rawhide Buttes, southwest of Lusk, Wyoming

SIX

A Time of Peace

June 1870

Crazy Horse had not yet married because he was still in love with Black Buffalo Woman. The gossip was that she still loved him too.

Over the years, Crazy Horse's people often camped near No Water's people. They were neighbors again in the summer of 1870 at Rawhide Buttes. Crazy Horse and Black Buffalo Woman could not have avoided each other even if they wanted to—and it was obvious they did not want to. Frequently others in camp saw them exchanging loving glances and softly conversing. Over the years, Crazy Horse had brought presents to Black Buffalo Woman, including many elk teeth. She used them to decorate a dress known for its beauty.

This behavior caused bad feeling between the Hunkpatila and Red Cloud's people, the Bad Faces. No Water's friends went to Crazy Horse's father—who took the name Worm after giving his name to his son—and told him there would be a fight if Crazy Horse tried to take Black Buffalo Woman as his wife. When Crazy Horse learned about this, he chose to ignore the warning.

One day when No Water was away from camp, Black Buffalo Woman left her three children with relatives. Later, when Crazy Horse rode out with his war party, Black Buffalo Woman rode proudly beside him.

June 1870

It was the right of a Sioux woman to leave her husband for another. Black Buffalo Woman had done nothing wrong; neither had Crazy Horse. But No Water had always been jealous of Crazy Horse and resented the attention he paid to Black Buffalo Woman.

No Water's friends sent word to him about what had happened. Immediately he set out after Crazy Horse. He found his camp north on the Powder River.

Waving a revolver, No Water burst into Crazy Horse's tipi. Crazy Horse jumped up while reaching for his knife. His friend Little Big Man, also in the tipi, grabbed and held Crazy Horse's arm as No Water fired. The bullet hit Crazy Horse below the nose, traveled across his cheek, and fractured his jaw as it exited. Fearing that No Water would try to kill her too, Black Buffalo Woman ran from the tipi. No Water ran after her, but she eluded him.

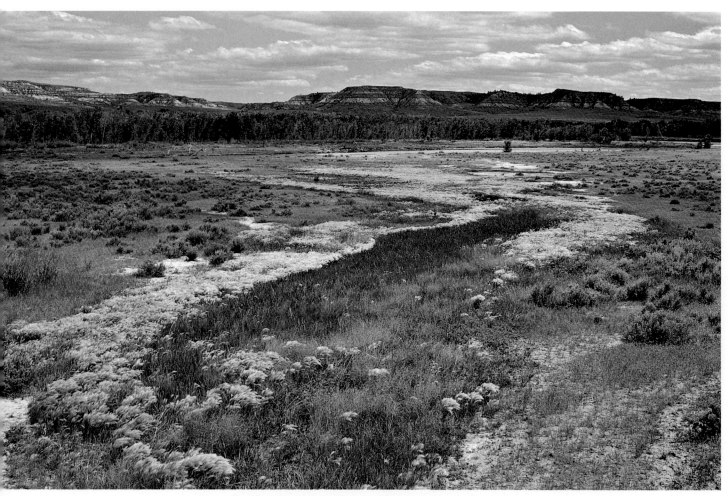

Powder River, near Montana/Wyoming state line

July 1870

Crazy Horse did not die from No Water's wound, but it was several weeks before he felt well enough to be up and about.

In the meantime, Black Buffalo Woman returned to No Water. Although No Water had intended to kill Crazy Horse, he was glad now that he had not; if Crazy Horse had died, there would have been fighting among the Oglala, and no one wanted that. To make amends, No Water sent three fine ponies to Worm. According to custom, this ended the matter; but it did nothing to change Crazy Horse's dislike for No Water.

When Crazy Horse was troubled, he went off by himself to hunt—a pursuit he loved. Hunting relaxed him and cleared his mind. He needed that now. Because he was still recovering from his gunshot wound, he asked He Dog to accompany him to the hunting grounds on the Yellowstone River.

The loss of Black Buffalo Woman was not the only thing troubling Crazy Horse. He had also been stripped of the honor of shirt-wearer. It was deemed that, with the Black Buffalo Woman incident, he had disrupted the peace of the people.

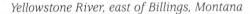

Yellowstone River, east of Billings, Montana

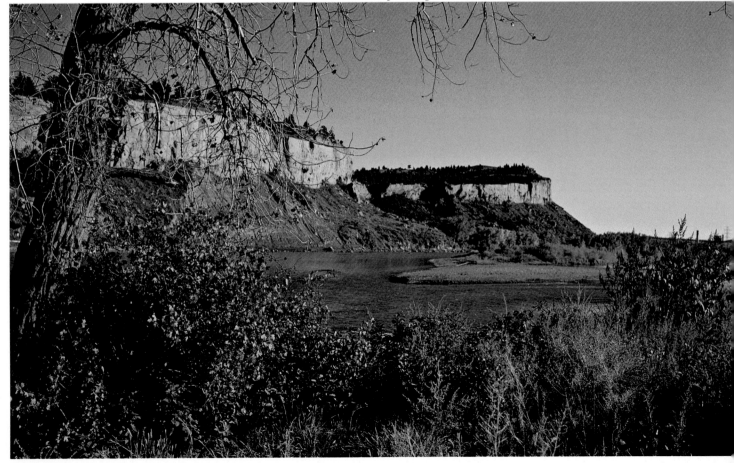

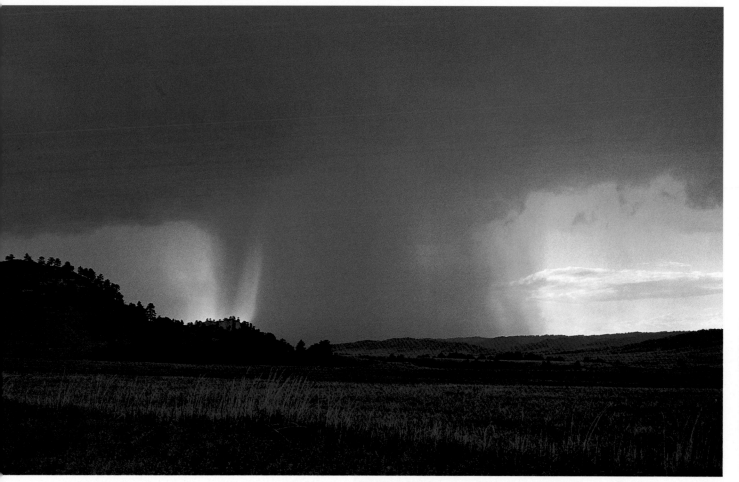

Rainstorm over the prairie

August 1870

While Crazy Horse was hunting on the Yellowstone, his brother Little Hawk joined a war party in Snake country. When Crazy Horse returned, he learned that Little Hawk had been killed—not by a Snake but by a white miner.

Finding it necessary to make a fast getaway, Little Hawk's companions had been unable to recover his body. That made it difficult for Crazy Horse to accept that his brother was really gone—laughing Little Hawk, who had ridden at his side in so many hunts and battles.

Blazing stars

September 1870

Crazy Horse was twenty-eight years old, many years past the time when most other Indian men had taken a wife. As it happened, a woman in camp who was about the same age as Crazy Horse had also not yet married. Her name was Black Shawl. She was the sister of Red Feather, one of Crazy Horse's close friends. Both Red Feather and He Dog encouraged Crazy Horse to take Black Shawl for his wife. Perhaps she could help ease his grief and despondency.

Crazy Horse and Black Shawl agreed to the arrangement. With little fanfare, Black Shawl moved into Crazy Horse's lodge and became his wife.

September 1870

Crazy Horse had a duty he felt he must perform. Shortly after their marriage, he and Black Shawl set out for the Holy Road in Snake country to look for Little Hawk's remains.

When they found his body, they wrapped it in a blanket and laid it on a scaffold they built in a safe place in an enemy land.

Oregon Trail ruts, vicinity of Jeffrey City, Wyoming

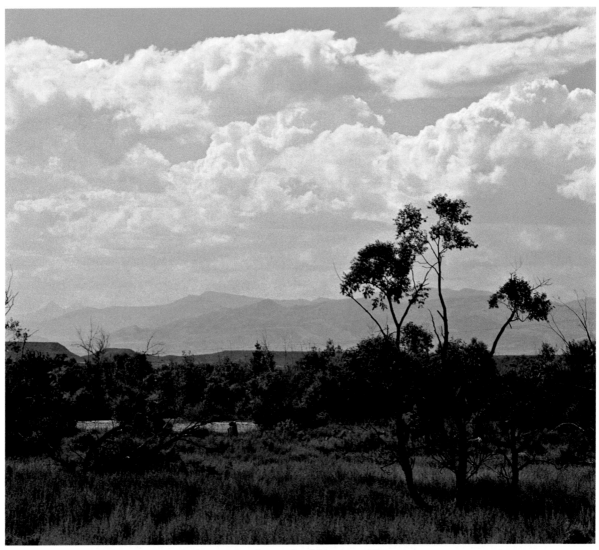

Badwater Creek, north of Riverton, Wyoming

October 1870

Crazy Horse had had more than his share of troubles in recent months—and they were not over yet. With Hump, he led a war party far into Snake country. When they met the Snake at Badwater Creek, a steady cold rain had turned the ground to ankle-deep muck in which the horses had trouble maneuvering. To add to their problems, the Oglala were badly outnumbered, and the Snake well-armed. Crazy Horse and Hump each had one of their party's three guns.

As the Oglala retreated, Hump was killed. The Snake closed in so rapidly that Crazy Horse could not stop to retrieve Hump's body. He rode back to camp disconsolate. Now the deaths of two loved ones weighed heavily upon him.

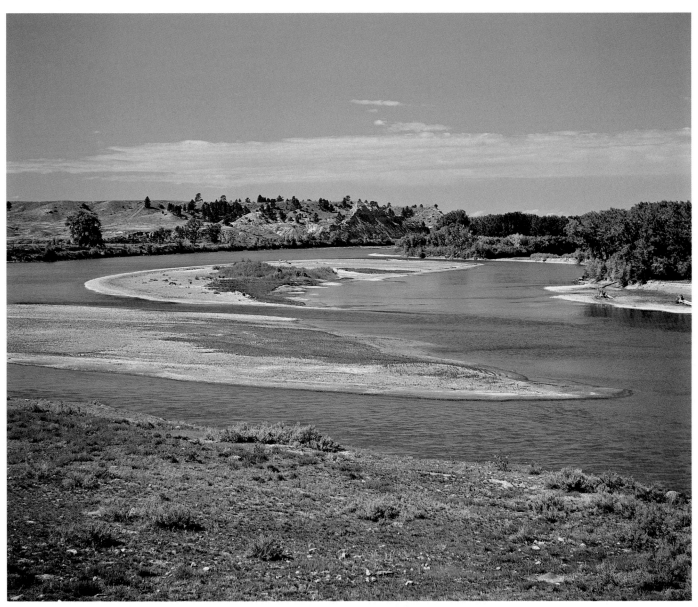

Mouth of the Rosebud River, east of Forsyth, Montana

Winter 1870–1871

With Black Shawl doing her best to comfort and cheer him, Crazy Horse wintered with his people on the Yellowstone at the mouth of the Rosebud River.

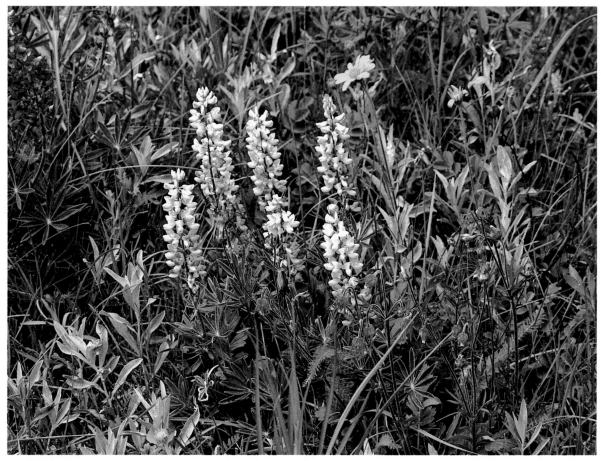

Lupine

Autumn 1871

Something happened to ease the loss of Little Hawk and Hump: a daughter was born to Black Shawl and Crazy Horse. Believing she would grow up to have great powers, Crazy Horse named her They-Are-Afraid-of-Her.

All Sioux loved children, but Crazy Horse absolutely doted on his daughter. He spent hours with her, playing, laughing, and enjoying himself. At last, it seemed, he had put his grief behind him.

A few months before, Black Buffalo Woman had also given birth—to a light-skinned daughter. No Water had taken another wife and Black Buffalo Woman lived apart from him with her youngest child.

Summer 1872

The annual council and sun dance took place at a camp on the Yellowstone River. As was his custom, Crazy Horse did not participate in the dance.

At the gathering, he renewed his friendship with Sitting Bull. They were of like mind: neither wanted any association with the whites. They wanted only to be left alone on their lands, and they were prepared to fight for this until they achieved it.

Yellowstone River, east of Forsyth, Montana

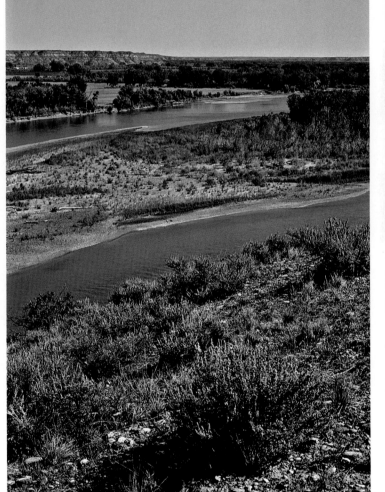

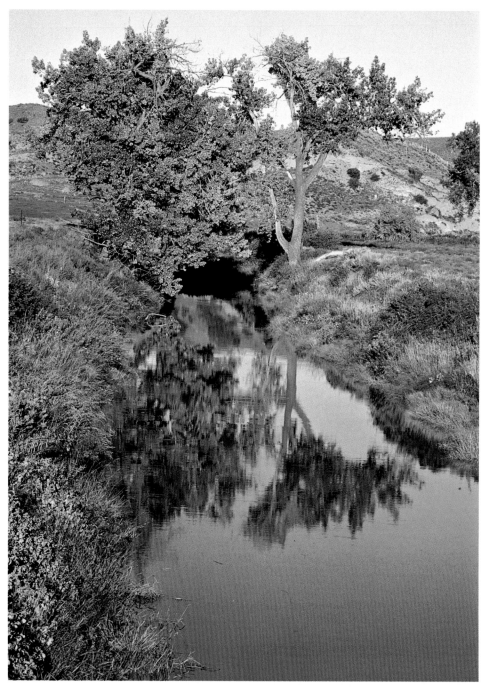

Arrow (Pryor) Creek, near Worden, Montana

SEVEN

New Troubles Begin

August 1872

Protected by a sizable body of troops, a survey crew for the Northern Pacific Railway set up camp on Arrow Creek, a tributary of the Yellowstone. Nearby, Crazy Horse, Sitting Bull, and their warriors waited to attack by daylight.

But it happened again: a few fervid warriors spoiled the surprise of the attack, giving the soldiers time to prepare. Several Lakota were killed and wounded. The Indians withdrew, chafing at the opportunity lost.

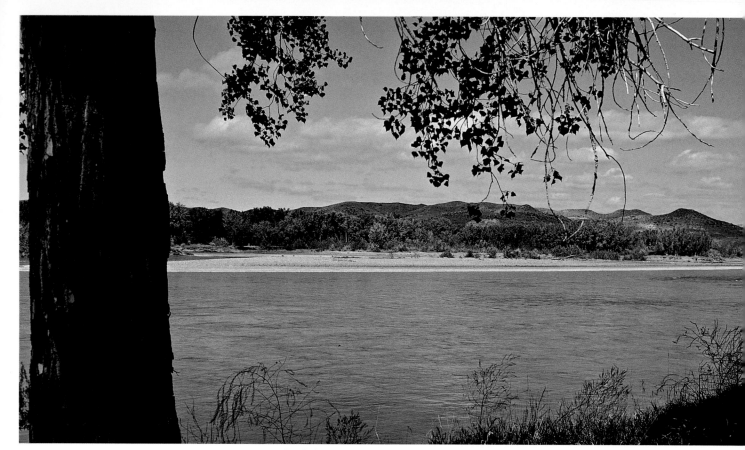
Mouth of the Tongue River, Miles City, Montana

August 4, 1873

Late in 1868, General George Armstrong Custer attacked Black Kettle's Cheyenne on the Washita River. Afterwards, many of the Cheyenne rode north to join Crazy Horse. Some were with Crazy Horse as he rode to scout out the railroad crew that had returned once again.

That summer, Custer was in charge of the troops accompanying the survey crew. From a bluff above the mouth of the Tongue River, Crazy Horse watched as Custer halted his troop of eighty-five men to wait for lagging foot soldiers and cavalry. The Cheyenne pointed out Custer, or Long Hair, as they called him. His shoulder-length blond hair made him easy to spot.

Crazy Horse had over three hundred warriors, but with few guns, they could not fight the soldiers effectively. Still, they thought they might be able to capture some of their horses, which were grazing nearby. The main body of warriors hid in a timbered area while a decoy party rode out. Custer, however, recognized the decoy trick and could not be lured into the trap. Instead, he led his full force in a mounted charge against the Indians, who immediately fled.

The Indians' quick retreat reinforced a belief Custer shared with most army officers: faced with the superior discipline and firepower of the army, Indians always ran.

August 11, 1873

A few days later, Custer and Crazy Horse met again farther up the Yellowstone, west of the mouth of the Little Bighorn River. Custer and his men were in a secure position on the north side of the Yellowstone when Crazy Horse and his band crossed the river to attack.

Custer saw them approaching and immediately ordered his men to mount up. With the band playing, he led the charge. Again the Indians fled. Custer pursued them for nine miles, but the heavily laden army horses could not overtake the fleet Indian ponies.

Pompeys Pillar, west of Custer, Montana

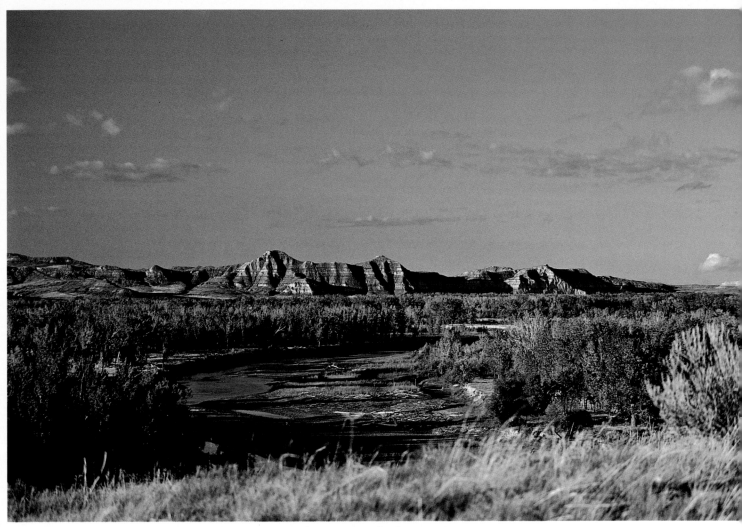

Powder River, south of Terry, Montana

Winter 1873–1874

Crazy Horse again had a winter camp on the Powder River. It was a bad time for him and his people. Black Shawl was sick and coughed much of the time. The people had little to eat and not much ammunition for hunting buffalo from the now severely depleted herds.

As if this weren't enough, disturbing news added to their woes. They learned that Red Cloud's agency had been moved north from the North Platte River to the White River. This meant many whites would be bringing supplies to the agency—in the process, traveling through Indian lands, where they were not supposed to go.

February 1874

Troubled by so many things during the long winter, Crazy Horse journeyed south alone to a lake called the Medicine Water to seek a vision.

Many of his ancestors had gone there and had had great visions.

After several days at the lake, Crazy Horse had neither vision nor dream. He returned to his camp as troubled as before.

Lake De Smet, Wyoming

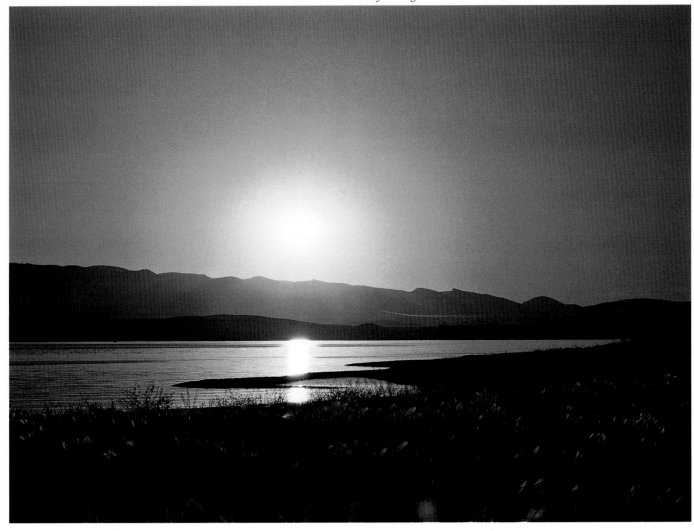

Spring 1874

After the weather improved, Crazy Horse and his warriors went off again to fight the Crow. When they returned, they found the camp had been moved. They had no trouble finding the new camp, though; their people had left sticks on the ground pointing the way to it.

When they got there, instead of the usual shouts of greeting, silence pervaded the camp. Worm came out to meet Crazy Horse and gently informed him that his daughter had died.

The death of his beloved child filled Crazy Horse with inconsolable grief—and intensified his anger toward the whites. They-Are-Afraid-of-Her had died of whooping cough—another disease the Indians had never known until the white men came.

Crazy Horse traveled back the many miles to his daughter's death scaffold. He climbed it and held the tiny, blanket-wrapped bundle for three days and nights, neither eating nor sleeping.

When he returned to camp, he was even more withdrawn than usual. He had always been quiet, but now he rarely spoke. This would be his mood for the rest of his life.

Wild asters

May 1874

It seemed that the heart had gone out of Crazy Horse. The warriors noticed that he was more reckless in battle, almost as though he were seeking death.

He often went out alone, raiding, harassing, and killing whites whenever the opportunity presented itself. They had caused all his troubles, one way or another, he reasoned; therefore, to him, it was vengeance that was just.

On one of his forays, he attacked four soldiers outside Fort Fetterman and dared to chase one of them across the parade ground before riding away.

Fort Fetterman State Historic Site, northwest of Douglas, Wyoming

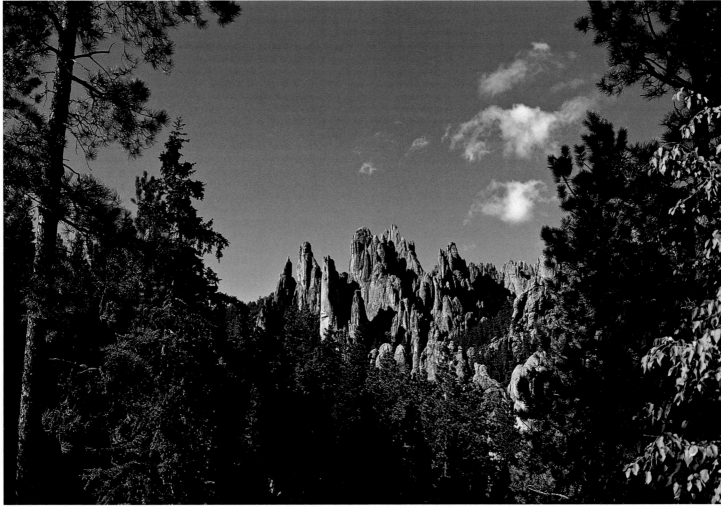

The Needles, Black Hills, South Dakota

❧ EIGHT ❧
The Invasion of Paha Sapa

July 1874

Custer and twelve hundred men invaded the sacred Paha Sapa on a reconnaissance expedition. Nothing the whites had done heretofore enraged the Indians so much. Not only was Paha Sapa a holy place, it belonged to the Indians as set forth in the Treaty of 1868. In the Indians' eyes there could be no justifiable reason for violating their lands. The treaty, however, had given the army the right to enter any Indian lands whenever it was deemed necessary—another provision not made known to the Indian signers.

Custer's expedition accidentally found gold in the Paha Sapa. As with other gold strikes, fever gripped many whites when they heard the news.

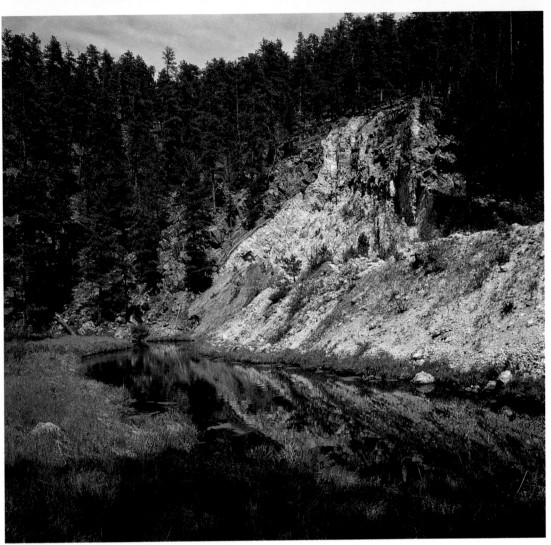

French Creek, Black Hills, south of Custer, South Dakota

Autumn 1874

The miners arrived in Paha Sapa in droves. This inflamed Crazy Horse. Often he went by himself to wreak vengeance on the invading whites.

The miners did not know who was responsible for the killings, but Indians knew. The dead miners were not scalped.

September 4, 1875

Crazy Horse's raids did not stop the miners; the hills were swarming with them. Government officials summoned Red Cloud and Spotted Tail to Washington to clear up the misunderstanding about the Black Hills.

They returned with the news that the government wanted to purchase the Black Hills from the Indians, along with the Powder River country.

On September 4, government commissioners arrived at the Red Cloud Agency. Lakota bands received word to send a delegation to meet with the commissioners. In response, Crazy Horse moved his camp to the Cheyenne River, close to the Red Cloud Agency, and dispatched his delegation. He himself did not attend, keeping up his usual practice of not associating with whites.

Crazy Horse and his followers were immovable about retaining Lakota ownership of the Black Hills. They felt so strongly about it that Little Big Man, a member of Crazy Horse's delegation, threatened to kill the commissioners. His announcement incited the other warriors. They began milling around, trying to provoke the soldiers guarding the commissioners. With seven thousand Indians in attendance, it was a dangerous situation. Young-Man-Afraid, who had been living at the agency, and some Indian police managed to calm the warriors and told them to go home. They departed without further incident.

The commissioners left a few days later without reaching any agreement, even though Red Cloud and Spotted Tail, without any authority to do so, offered to sell the Black Hills for seven million dollars.

The commissioners concluded that the Indians should be taught a lesson.

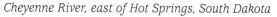

Cheyenne River, east of Hot Springs, South Dakota

February 1876

With nothing resolved about the Black Hills, Crazy Horse and other Lakota bands moved northwest to the Powder and Tongue Rivers for the winter.

In Washington, officials dealing with the Indian problem were in a quandary. They wanted control of the Black Hills and the Powder River country. The non-agency Indians—hostiles, as all free Indians were called—were an obstacle to this goal. On December 6, President Ulysses S. Grant had ordered all hostiles to move to the agencies in less than two months—by the end of January. Messengers had been sent to notify all the Indian bands in the north.

Crazy Horse was camped on the east fork of the Little Powder River when the news reached him. He felt it did not pertain to him. Whites had no business telling him what to do. He was living peacefully on his own lands as he had a perfect right to do, and he intended to go on living freely.

Many Indians shared Crazy Horse's opinion, but others decided to go in. Most of the latter would not be able to make it to the agency by the deadline because of the heavy snow on the ground, but they indicated they would come in when the weather improved.

He Dog, who was visiting in Crazy Horse's camp, decided to go in. He knew Crazy Horse might not approve of his decision. Indeed Crazy Horse was saddened by his old friend's choice. But he believed, in the Lakota way, that each person should follow his own course.

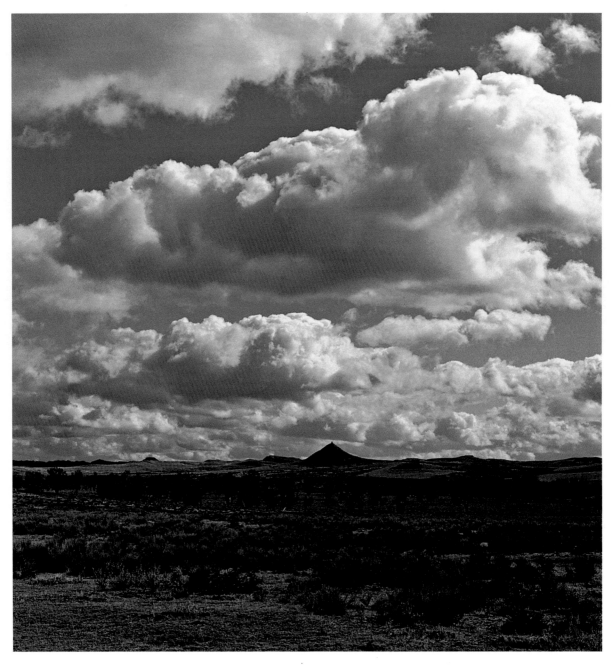

East Fork of the Little Powder River, southeast of Broadus, Montana

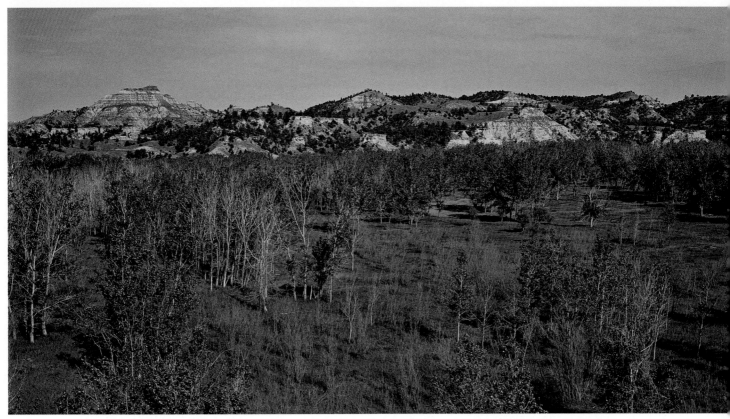

Site of the villages of Two Moon and He Dog, Powder River, northeast of Moorhead, Montana

March 17, 1876

He Dog and his people left Crazy Horse's camp to join Two Moons and his Cheyenne, who were also going in to the agency. On the way, they camped on the Powder River about forty miles south of Crazy Horse's village.

When the hostiles had not arrived by the appointed time, General George Crook, with his force of eight hundred men, was ordered to go against the Indians. Army commanders reasoned that winter was an opportune time for such a campaign; settled into their lodges, the Indians would be taken by surprise and unprepared to fight.

When his scouts discovered a village, Crook ordered the cavalry under Colonel J. J. Reynolds to attack at dawn. As the troops charged into the camp, most of the Indians were able to flee into the hills to the west. The soldiers captured many of their horses, however, and burned their tipis and supplies.

Crook sent word that Crazy Horse's village had been destroyed. He was, of course, mistaken.

He Dog and the other survivors had no time to gather clothes or supplies before they fled, which left them ill-clad and poorly equipped for the bitter cold weather. It took them four days to make their way back to Crazy Horse. Just as they straggled into camp, Crazy Horse received word that, supposedly, his village had been wiped out. But for the matter of a few miles, it might have been true.

March 27, 1876

Crazy Horse's people gave He Dog and the refugees all the supplies and clothing they could spare, but there was not enough to go around. To provide for them adequately, Crazy Horse moved his people north to the Chalk Buttes, to the large camp of Sitting Bull.

Because of Reynolds's attack, most of the Indians who had intended to go to the agency changed their minds. Instead, the chiefs called a war council.

Chalk Buttes, southwest of Ekalaka, Montana

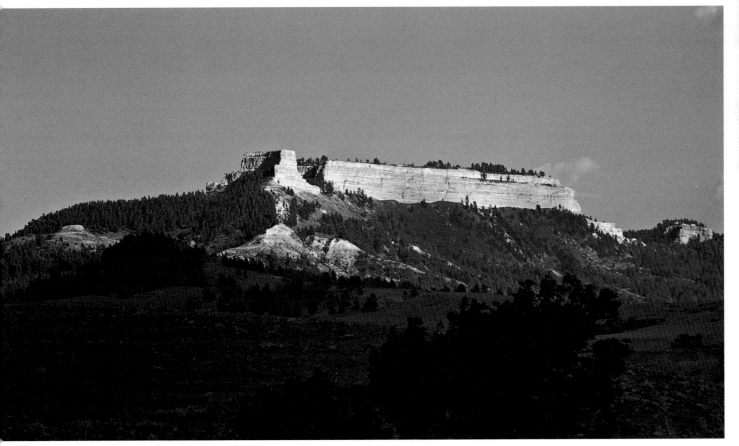

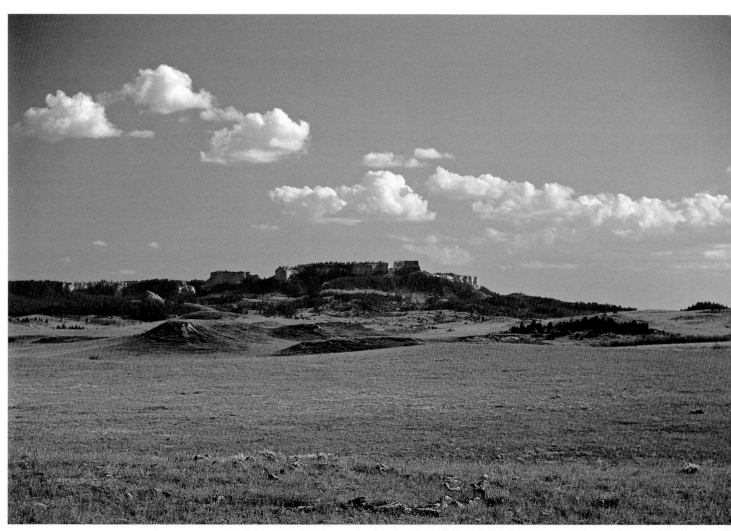

Tipi ring, Chalk Buttes, southwest of Ekalaka, Montana

NINE

A New Chief Takes Over

April 3–8, 1876

The Oglala knew that, to maintain their freedom, they would have to fight together. For this they needed what they had never had before: one chief to lead all the people. Only one among them commanded this level of respect: Crazy Horse, with his powerful medicine.

The Indians made preparations for a great celebration. They erected sweat lodges and two large ceremonial tipis, encircling the bottom edges with stones. When all was ready, Crazy Horse was installed as war chief for life.

Runners spread the word that Crazy Horse was now their leader, and announced that a war council was to be held.

Indians began gathering from near and far to attend the council. Thousands of agency Indians left to join Crazy Horse. One of them was Red Cloud's own son.

June 4, 1876

Nearly two months had passed since word went out about the war council. The camp at Chalk Buttes swelled to over ten thousand people, made up of Oglala, Cheyenne, Minneconjou, Hunkpapa, Sans Arc, Santee, Brulé, and Blackfoot Sioux.

As the gigantic pony herd drifted from one grazing ground to another, the camp gradually moved southwest to Deer Medicine Rocks on the Rosebud River. Since the time of the ancients, these rocks had been a sacred place where people offered prayers and carved medicine symbols in the sandstone.

A great sun dance was to be held on a wide, level plain nearby. Many of the Indians knew in their hearts that this would be the last time they would all be together like this.

Detail of petroglyph, Deer Medicine Rocks, north of Lame Deer, Montana

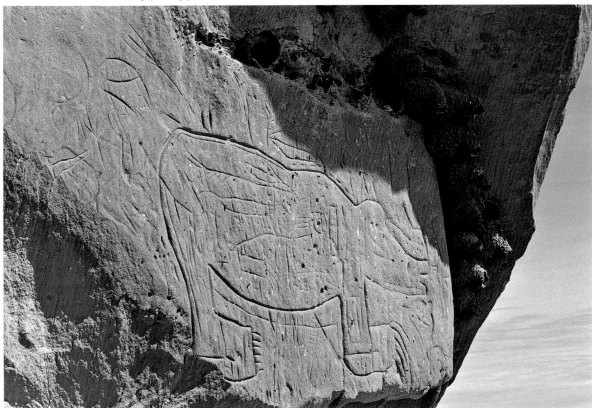

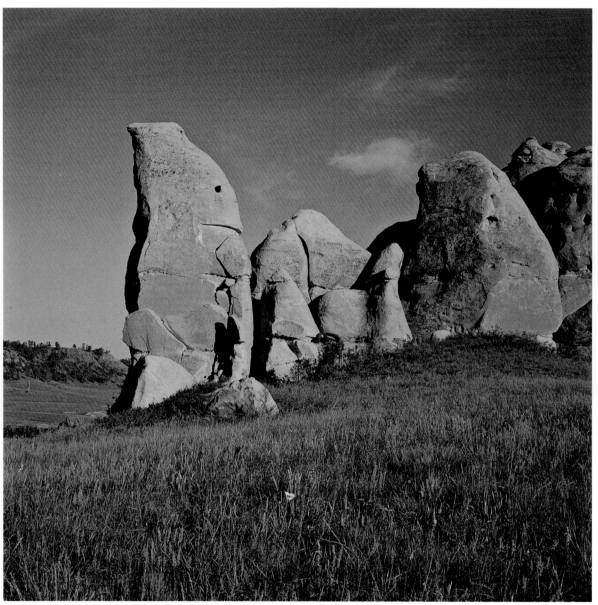

Deer Medicine Rocks

Sun dance site, Rosebud River, north of Lame Deer, Montana

June 5–7, 1876

Crazy Horse had never taken part in a sun dance and again he did not. The most noteworthy participant was Sitting Bull. He hoped to have a vision during the dance.

Sitting Bull prayed to Wakantanka, the Great Spirit. He vowed to give one hundred pieces of his flesh to aid in seeking a vision that would foretell the future of the Lakota people. With a sewing awl he pricked the skin on each of his arms in fifty places, then lifted and sliced each piece off with a sharp knife.

After Sitting Bull had sat for two days staring at the sun, a vision came to him. He saw soldiers falling from the sky, upside down, into a large Indian encampment. This was interpreted to mean that the soldiers would attack the camp, a great battle would take place, and the Indians would be the victors.

June 15, 1876

After the sun dance, the Indians made their way to Ash Creek, which flowed west from the Wolf Mountains. Although it would have been more practical to split into smaller villages as they usually did, they believed that Sitting Bull's vision prophesied that they would be invincible if they stayed together in one band.

At Ash Creek, scouts brought the news of many soldiers moving north on the Rosebud. Crazy Horse and other chiefs began assembling war parties to intercept them.

At a council, tribal leaders asked Crazy Horse to lead the warriors in battle. He agreed—but only if they fought differently from the usual Lakota way. The change was necessary, he said, because this fight would not be for counting coup and showing bravery through reckless deeds. It would be a battle for killing.

Wolf Mountains, southeast of Crow Agency, Montana

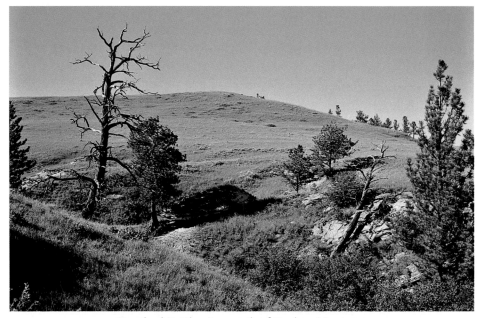

Rosebud Battle site, north of Decker, Montana.
The Indians charged over this ridge to attack Crook's troops.

June 17, 1876

General Crook's detachment stopped to rest at eight o'clock in the morning in the valley of the Rosebud River, not far from its headwaters. With a war party of some fifteen hundred Lakota and Cheyenne warriors, Crazy Horse rode to attack Crook's column as it prepared to move down the river.

Breasting a ridge to the north, Crook's Crow scouts surprised the war party in a hollow below. Crazy Horse and his warriors pursued the scouts back over the ridge and through a narrow breach, then charged Crook's force. Although repulsed and driven back up the hill, the Indians were able to make a defensive stand. Crazy Horse urged his warriors on: "Be strong! Brave hearts to the front; weak hearts to the rear! This is as good a day to die as any day!"

More warriors joined the fighting. Over an area of several miles, battles raged all day on the hills and in the valley. Crazy Horse and his followers charged, retreated, and counter-charged again and again. As the day waned, the Indians began to run out of ammunition and withdrew.

The next day, having incurred considerable casualties and lost many supplies and horses, Crook retreated south to his base on Goose Creek.

Neither side gained or lost decisively. Even so, the battle was significant. It was the first time the Lakota had ever fought as a single, cohesive force. And it was Crazy Horse's leadership that had united them.

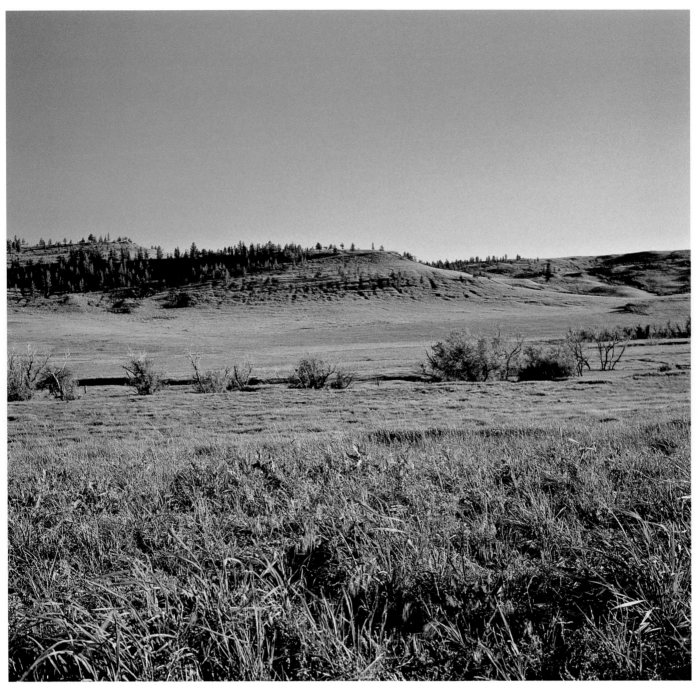

Rosebud Battle site: the Rosebud River Valley, where Crook's troops were resting.
Indians attacked the south ridge (shown) where Crook had positioned a detachment.

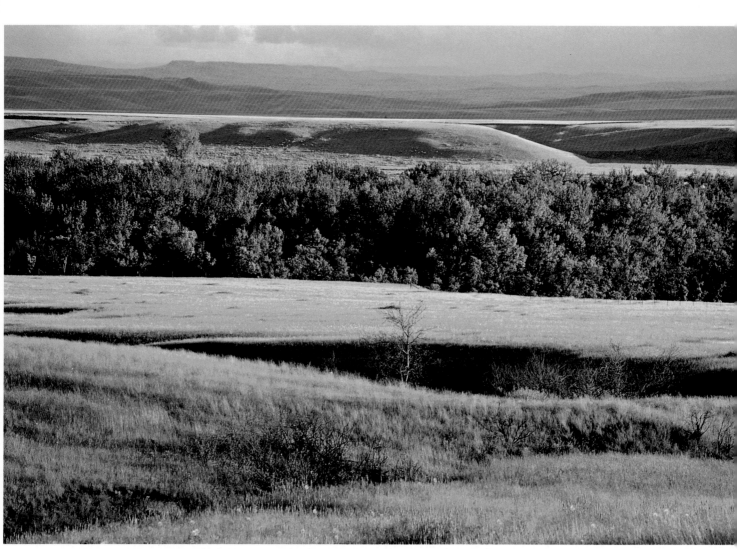

Valley of the Little Bighorn River, looking west toward the site of the Indian camp

TEN

The Battle of the Little Bighorn

June 18, 1876

The Indians made camp in the valley of the Little Bighorn River, where they hoped to find a plentiful supply of game and more grass for the ponies. The villages of the various tribes extended for three miles along the west bank of the river.

Having used up much of their scanty ammunition supply in the fight on the Rosebud, the warriors sent some of the older boys back to glean the battlefield for scattered ammunition, empty cartridges, bits of lead, jammed guns that had been cast aside, and arrowheads—anything they could use in the next battle. They knew there would be one. The fight on the Rosebud had not fulfilled Sitting Bull's vision of soldiers falling into camp.

June 25, 1876

In the morning and early afternoon, the adults in the huge Indian encampment went about their usual duties while the children frolicked in the Little Bighorn River.

2:45 P.M.

Scouts brought word of a large dust cloud to the southeast. It could only mean a sizable body of fast-moving soldiers. Runners spread the word through the camp.

3:00 P.M.

By the time Crazy Horse and his warriors reached the village of the Hunkpapa at the south end of the encampment, Major Marcus Reno's troops had arrived and were attacking.

Crazy Horse noticed the soldiers' guns were jamming. He seized the opportunity created by reduced firing and led a charge. The soldiers' line was broken, and they were forced to fall back into woods beside the river. The Indians pursued them into the trees.

3:45 P.M.

When the soldiers reached the shelter of the trees, they dismounted; then, in utter confusion, they remounted and began a swift, disorganized retreat through the warriors toward the river. The Indians swept upon the soldiers, firing their guns and arrows and knocking many of them from their saddles.

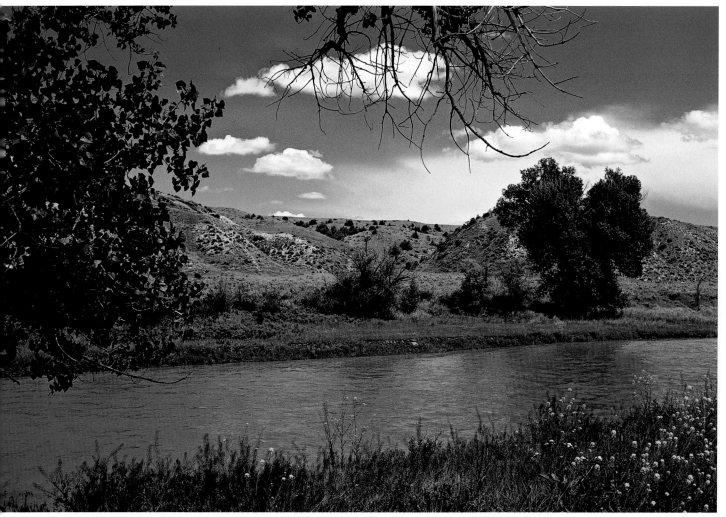

Site of Reno's retreat across the Little Bighorn River,
Little Bighorn Battlefield National Monument, Crow Agency, Montana

3:50 P.M.

Plunging their horses into the Little Bighorn, urging them up the steep bluff on the other side, the soldiers left behind many dead and wounded.

A messenger arrived in camp with more news: soldiers were coming over a ridge on the other side of the river, farther downstream.

It was Custer with five cavalry companies.

Crazy Horse galloped back through the camp, mounted a fresh horse, rallied more warriors, and rode downriver to meet this new threat.

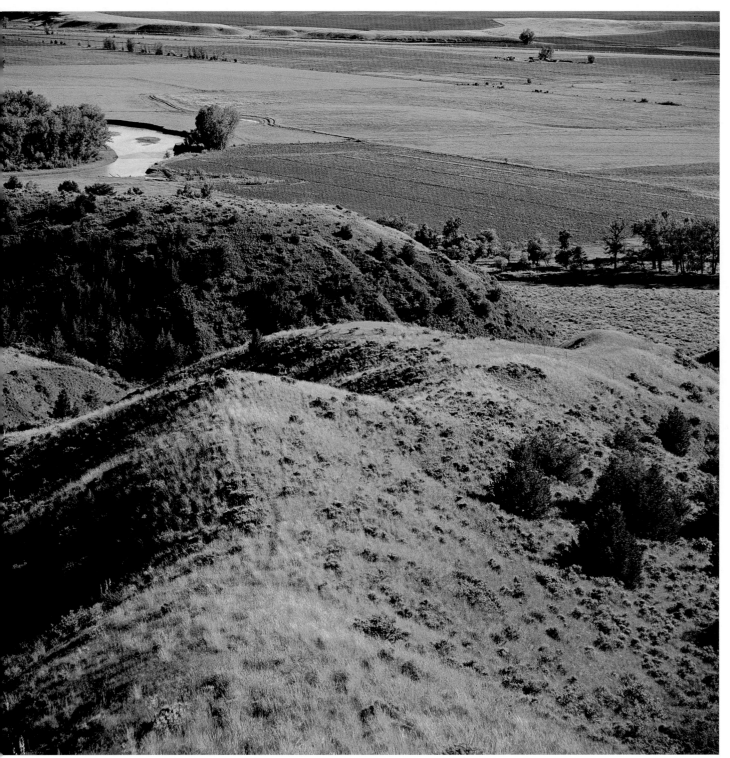

Bluff up which Reno and his troops retreated,
Little Bighorn Battlefield National Monument, Crow Agency, Montana

4:00 P.M.

Custer was looking for a place to cross the Little Bighorn to attack the Indian camp directly. Where the ridge sloped off into a valley, he saw Indians streaming across a ford below. Through sporadic firing from the Indians, he and his men traversed the head of the valley onto another ridge, continuing north in their search for a river crossing. Custer's troops straggled out behind him; their horses had been at a gallop for some time and were tiring rapidly.

After forcing Reno and his troops to retreat, Hunkpapa and Cheyenne warriors rode across the ford and began attacking the rear of Custer's column. The soldiers dismounted and formed a defense. Meanwhile, other Indians began attacking the middle of the column. These soldiers also dismounted to fight on foot.

Indians concealed in the tall grass kept up a steady rain of arrows, hitting men and animals. Horses shied and bolted, taking with them the reserve ammunition that troopers carried in their saddlebags. A group of mounted soldiers charged the Indians in the grass but succeeded only in becoming cut off from the rest of the troops.

4:05 P.M.

Custer and the rest of his men reached the top of a small hill. He intended to rally his troops there and make a stand.

Crazy Horse and his large force had ridden downriver, north of Custer, and had crossed to the other side. Just as Custer arrived at the top of the hill, Crazy Horse and his warriors charged up a ravine behind him, cutting off retreat in that direction.

Ravine up which Crazy Horse and his warriors charged to the southeast to attack Custer's position on the hill. Little Bighorn Battlefield National Monument, Crow Agency, Montana

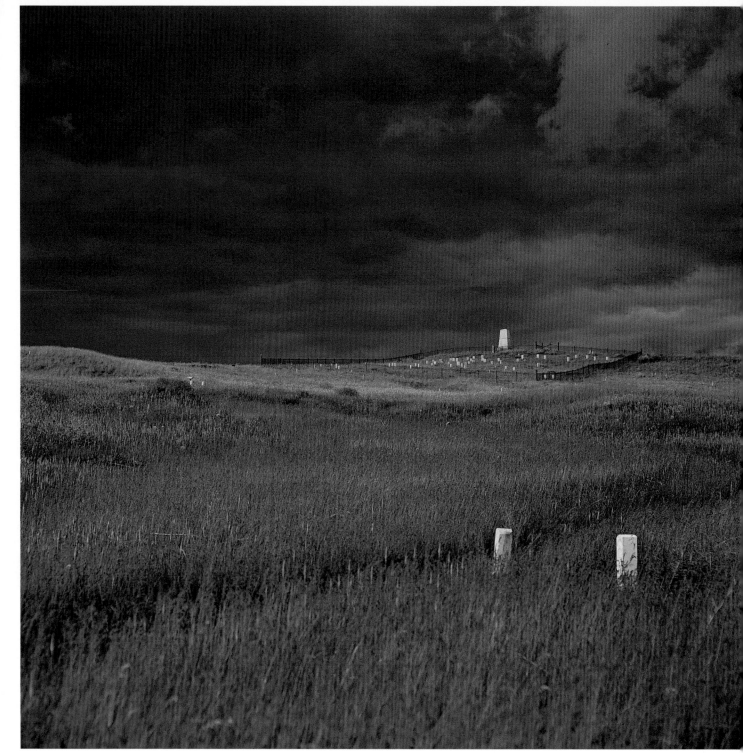

*Custer Hill, looking northeast from Deep Ravine Trail (white markers indicate where soldiers died),
Little Bighorn Battlefield National Monument, Crow Agency, Montana*

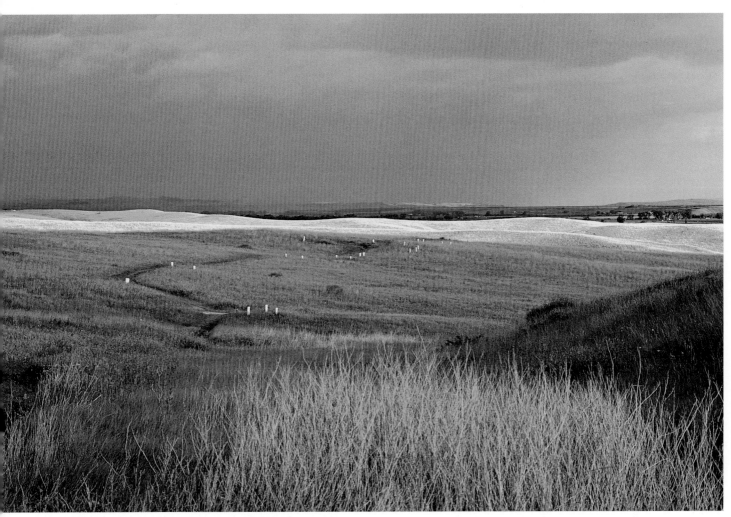

Below Custer Hill looking towards the Little Bighorn River, where some of the troops of E company died, Little Bighorn Battlefield National Monument, Crow Agency, Montana

4:15 P.M.

As Crazy Horse crested the hill, another group of warriors swooped in from the other side, trapping Custer.

4:30 P.M.

Disorganized, separated into scattered small groups, Custer's companies fought for their lives.

4:45 P.M.

Custer and his remaining men shot their horses and barricaded themselves behind the dead animals.

Crazy Horse led charge after charge against the soldiers. He shouted and urged his warriors on as he had at the Rosebud: "Be brave! It is a good day to die!"

The fighting was close and heavy. When the soldiers' guns jammed or ran out of ammunition, the Indians moved in with clubs, spears, and arrows to finish them off.

One by one the soldiers fell until none were left alive.

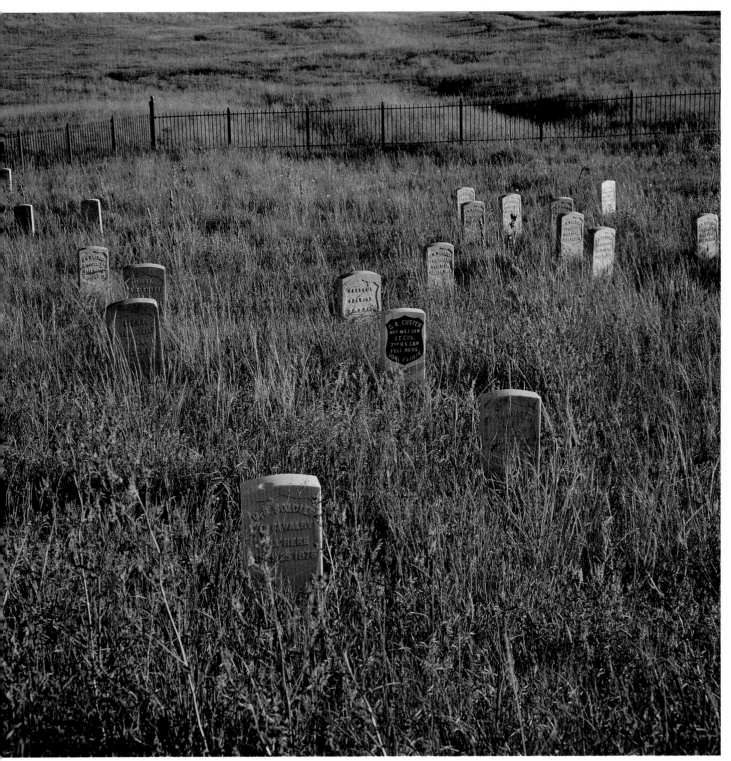

Custer Hill (black marker denotes where Custer fell),
Little Bighorn Battlefield National Monument, Crow Agency, Montana

5:00 P.M.

The Indians noticed Captain Frederick W. Benteen and the remnants of Reno's troop advancing down the ridge from the south. The Indians left the hill to engage the new group. They drove them back down the ridge where the soldiers took a defensive position around a small depression.

All through the night and into the morning, the Indians harassed the soldiers, doing their best to keep them away from the river and the water they desperately needed.

The Indians ended the engagement when word came that more soldiers were marching down the Bighorn River from the Yellowstone.

They broke camp and departed, satisfied that Sitting Bull's prophetic vision had come true.

Shallow depression (center) where the wounded of Reno's detachment were treated. Troops took a defensive position around the depression. Little Bighorn Battlefield National Monument, Crow Agency, Montana

Bighorn Mountains, Wyoming

ELEVEN

Continuing Confrontations

July 1876

After the battle on the Little Bighorn River, most of the Indians had had enough fighting for the summer. The many camps dispersed into small groups; it would be easier that way to elude the soldiers who were sure to pursue them.

Crazy Horse and his people moved south to the Bighorn Mountains to hunt and replenish their supply of lodgepoles.

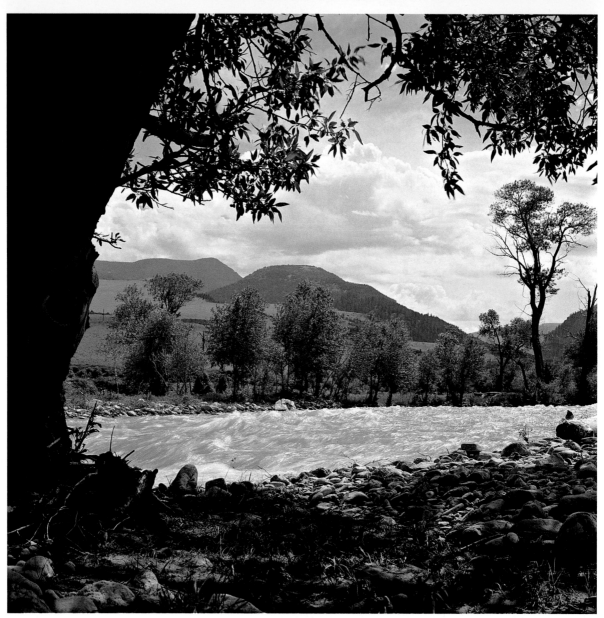

Little Bighorn River near the Montana/Wyoming state line

July 7, 1876

On their way to gather lodgepoles, some of the Indians came upon a scouting party led by Lieutenant Frederick W. Sibley, sent by General Crook to look for Indian encampments. After a short engagement, the Indians surrounded Sibley's party. Abandoning their horses and climbing the steep hills near the entrance to the Little Bighorn Canyon, the soldiers managed to escape.

August 1876

Summer waned. Crazy Horse and his people moved northeast until they reached the vicinity of the Little Missouri River, where they established a camp.

Many of the agency Indians who had been with Crazy Horse headed back to the agencies for the winter. Among them were Iron Plume and his band, who planned to rejoin Spotted Tail at his agency.

Medicine Rocks State Park, south of Baker, Montana

September 9, 1876

A small detachment led by Captain Anson Mills attacked Iron Plume's people while they were camped at Slim Buttes. The Indians dispatched a runner to Crazy Horse for help.

By the time Crazy Horse got to Slim Buttes, Crook and his troops had reinforced Mills's detachment. As the Indians were greatly outnumbered and severely short of weapons and ammunition, Crazy Horse soon withdrew his warriors.

The soldiers took many captives. Iron Plume was killed in the battle.

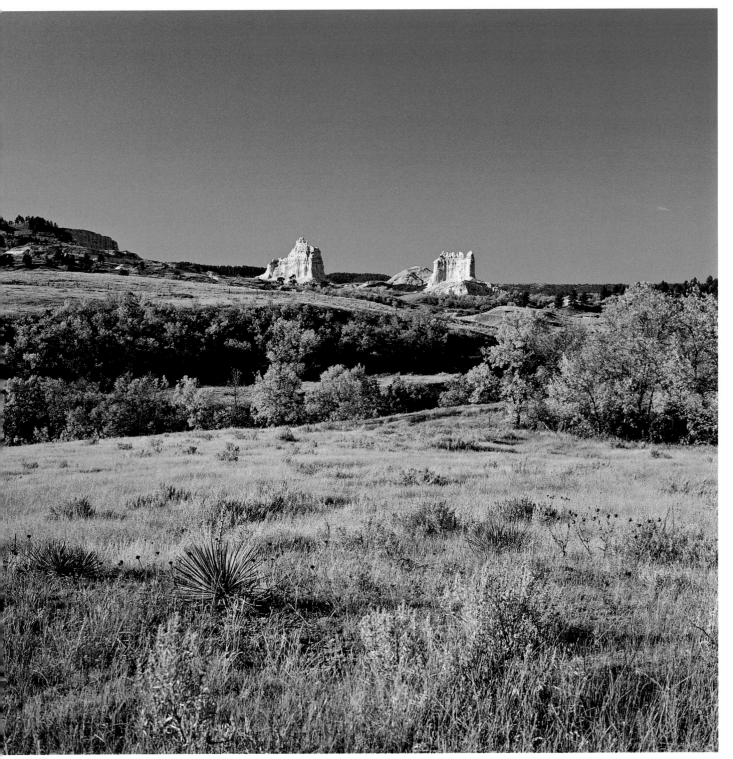

Slim Buttes, west of Reva, South Dakota

November 1876

The Black Hills were sold. Red Cloud and Spotted Tail signed them away even though the 1868 treaty stipulated that nothing could be done with Lakota lands unless three-quarters of adult male Lakota agreed. Because the government had stopped food rations to the starving Indians, Red Cloud and Spotted Tail knew they had no choice but to sign if their people were to survive.

December 1876

News of the sale of the Black Hills reached Crazy Horse while he and his people were camped on the Tongue River.

During the late summer, the army had established a cantonment at the mouth of the Tongue River on the Yellowstone. Colonel Nelson Miles was in command. He aggressively pursued the Indians and had several brief encounters with them. In one, he captured several Indian women.

Like other commanders, Miles wanted to have Crazy Horse under the army's control; furthermore, he wanted Crazy Horse to surrender to him and no one else. In December, he sent one of his Indian scouts to Crazy Horse's camp to ask him to give himself up. As a token of his good will, Miles sent along the women he had captured.

When the scout told Crazy Horse what Miles wanted—unconditional surrender—Crazy Horse did not reject the offer. He had been pondering for some time about what course he should follow. Hunting was bad, so food was in short supply. He was tired of fighting and knew his small, ill-equipped, and sparsely provisioned band could not hold out forever. He agreed to come in.

Crazy Horse moved his camp north along the Tongue to a location near the cantonment. He sent eight sub-chiefs under a white flag to meet with Miles. As the Indians approached, Miles's Crow scouts attacked and killed five of them.

Miles was furious. He knew his scouts' actions had destroyed any chance he had of getting Crazy Horse to surrender.

Again, Crazy Horse moved his camp, this time far away from the cantonment.

Tongue River, south of Miles City, Montana

January 8, 1877

Miles and his foot soldiers set off immediately in pursuit of Crazy Horse, but they did not catch up with him until almost two weeks later, many miles south on the Tongue River. He had set up his village on the south side of a low ridge.

From the ridge, the Indians repulsed several attacks by the soldiers and were able to hold them off until the people in the camp got away. Then they withdrew. Miles, running short of supplies, did not give chase.

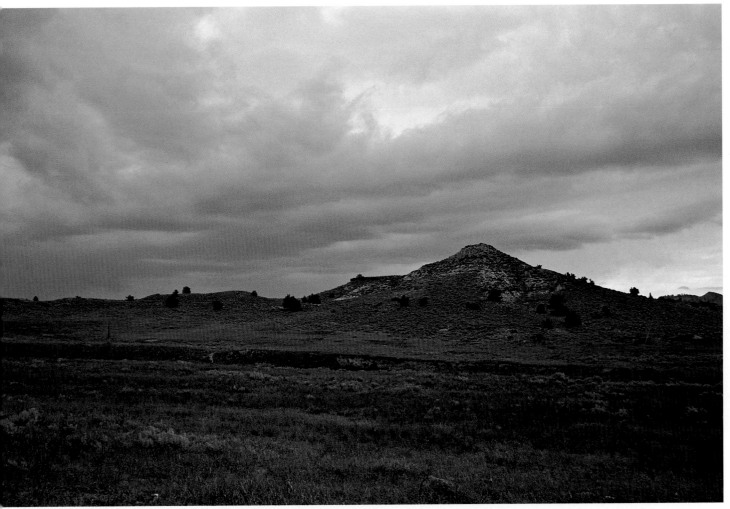

Battle (Wolf) Mountain, southwest of Birney, Montana

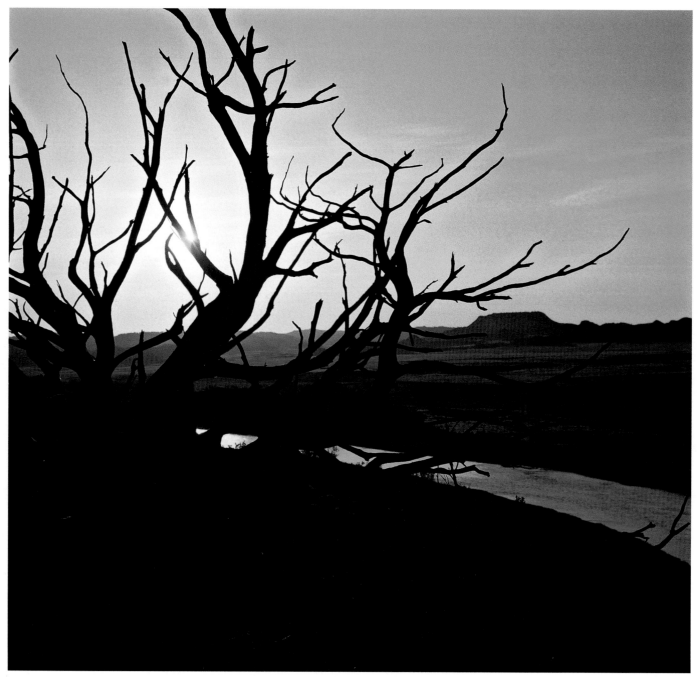

Little Powder River, south of Broadus, Montana

TWELVE
Crazy Horse Surrenders

February 1877

Since all of the army's efforts to get Crazy Horse to come in to the agency had failed, Crook decided to send one of Crazy Horse's own people to persuade him. He selected Spotted Tail for the mission. Spotted Tail brought a message from Crook to entice Crazy Horse: if Crazy Horse surrendered to Crook at Camp Robinson, he could have his own agency in the Powder River country.

When Spotted Tail and his party arrived at Crazy Horse's camp, now on the Powder River, Crazy Horse was not there. But he had left a message for Spotted Tail. He and his people would come into the Red Cloud Agency as soon as the weather was more favorable.

May 6, 1877

As the weather improved, Crazy Horse moved his village closer to Camp Robinson. On the fifth of May, it was a short distance northeast of the military camp.

The next day, Crazy Horse led his people down Dead Soldier Creek to surrender. All were resplendent in their finest clothes except for Crazy Horse, dressed in his usual plain buckskin shirt and blue leggings with a single eagle feather in his hair. He Dog, Big Road, Little Big Man, and Little Hawk—Crazy Horse's uncle, who had taken the name of his nephew after he was killed—rode beside Crazy Horse.

The whites from Camp Robinson and twenty thousand Indians from the nearby agencies gathered to watch. Those with Crazy Horse—eight hundred people with one hundred forty-five lodges and seventeen hundred ponies—made a colorful procession two miles long. No air of defeat hung over the parade, causing one army officer to remark angrily, "By God, this is a triumphal march—not a surrender."

Lieutenant William P. Clark had been delegated to escort Crazy Horse. When they met, Crazy Horse dismounted. He extended his left hand to Clark and said, "Kola"—the Lakota word for friend—"I shake with this hand because my heart is on this side. I want this peace to last forever."

Crazy Horse had no gifts or warbonnet to give to Clark as was the custom, so He Dog removed his warbonnet and scalp shirt and gave them to Crazy Horse, who then presented them to Clark. Clark accepted them graciously. Then he quietly informed Crazy Horse that all guns would have to be surrendered, but that this could wait until later after the women had raised the lodges and gotten settled.

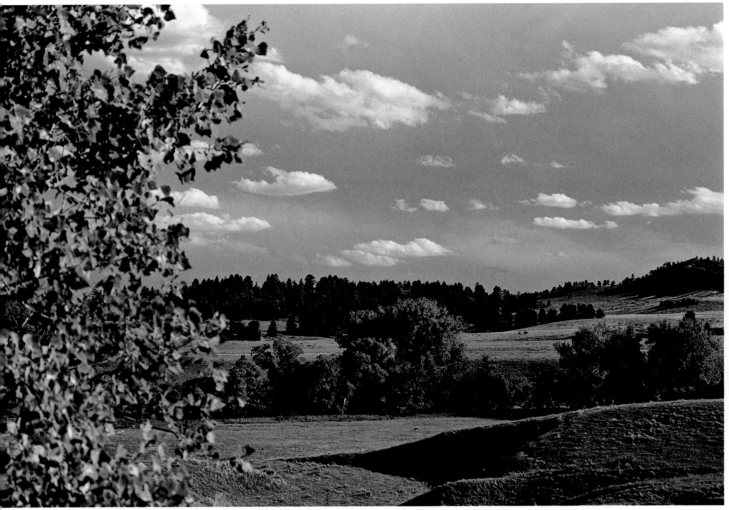

Dead Soldier Creek Valley, north of Fort Robinson State Park, Crawford, Nebraska

May 1877

Crazy Horse set up his permanent village on Cottonwood Creek near Crow Butte. The stream provided his camp with fresh water. There was no need to worry about grass for the ponies anymore because the army had confiscated them.

Spotted Tail's Agency was forty miles to the east; the Red Cloud Agency, a few miles southwest and one mile east of Camp Robinson.

The army now had all the hostile Lakota contained on reservation lands except for Sitting Bull, who had fled with his people to Canada.

Little Cottonwood Creek, near Whitney, Nebraska

Summer 1877

Crazy Horse often took his pipe and smoked and reflected in solitude on top of Crow Butte. He also hoped for a vision that would tell him what the future held for his people.

Some of Crazy Horse's captors became friendly with him. They admired him not only for his simple dignity and pleasant demeanor, but also for his leadership in fighting, as many adversaries do after the battles are done.

The army officers began to talk about making Crazy Horse head chief of all the Oglala. This, and hero worship of Crazy Horse among the Oglala and Brulé, fanned the jealousy of both Red Cloud and Spotted Tail. The whites had appointed them head chiefs, positions they had held for many years. They did not want to relinquish their authority, such as it was, to someone else—especially someone as young as Crazy Horse.

Crook also developed a friendship of sorts with Crazy Horse. At first, Crazy Horse accepted his friendship. Then, as Crook kept evading the issue of the promised Powder River agency, Crazy Horse became increasingly distant. He had no way of knowing that Crook had never had the authority to make such a promise.

To soothe Crazy Horse and to delay explaining that he was not going to have an agency, Crook told him that later he could go on a buffalo hunt in the Powder River country.

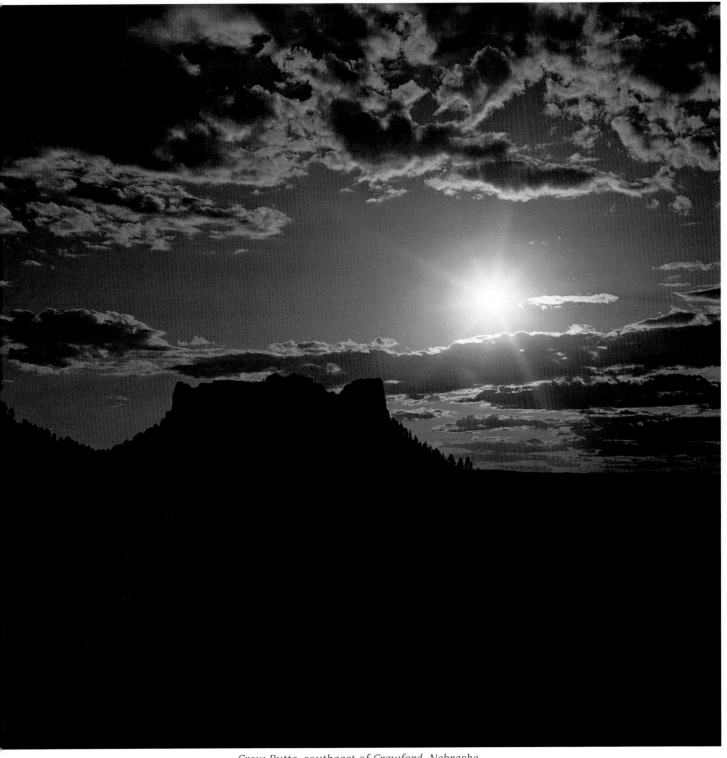

Crow Butte, southeast of Crawford, Nebraska

Throughout the summer of 1877, Crazy Horse waited for the promised hunt to materialize, but it never did. Crook always found an excuse for postponing it. Once, when he proposed that Crazy Horse journey to Washington to meet the Great White Father, Crazy Horse replied that he was not hunting for any great father, and refused to go. Dr. V. T. McGillicuddy, the post surgeon who was treating Black Shawl for tuberculosis, and who had become fast friends with Crazy Horse, urged him to make the trip. Crazy Horse reconsidered and intimated that he would visit the Great White Father, leading the army officers to believe that he was becoming more cooperative. As a reward, the officers began to do what they could to bring about the promised hunt.

Red Cloud and his followers spread rumors that if Crazy Horse and his people were allowed to go on a hunt, they would take the provided guns and horses and never return to the agency; they would go back to their wild ways. The officers called off the hunt.

Red Cloud did not want Crazy Horse to go to Washington. He was afraid the trip would elevate Crazy Horse even more in the eyes of the Lakota and thus diminish his own position.

Since it was common for Indians to have more than one wife, Red Cloud suggested to Lieutenant Clark that it might be good for Crazy Horse to take a second wife; perhaps it would help him settle down. Clark agreed. Nellie Larrabee, the half-Indian daughter of one of the post traders, had been attracted to Crazy Horse since she first met him. She had served as

interpreter for Dr. McGillicuddy when he was treating Black Shawl. Clark and Red Cloud also thought she might help Crazy Horse better understand the white man's ways. Crazy Horse consented to have Nellie as his wife. It was a good arrangement for both him and Black Shawl. He enjoyed having the newspapers read to him, and ailing Black Shawl had help with the work of the lodge.

During this time, farther west, the Nez Perce Indians under Chief Joseph had refused to move to a reservation and were headed east toward the old Lakota hunting grounds. Crook enlisted many Oglala as scouts to help round up the Nez Perce. Crook promised Crazy Horse a horse, a uniform, and a new repeating rifle if he would become a scout. Crazy Horse refused. He said he had come to the agency for peace and did not wish to go to war again forever. Clark also persistently pressured Crazy Horse to join the scouts; he insisted they needed his services. Finally, an irritated Crazy Horse said he would go to the Powder River with Crook and fight "until there wasn't a Nez Perce left." Frank Grouard, an enemy of Crazy Horse, was interpreting. He told Clark that Crazy Horse said he would fight "until there wasn't a white man left."

The next day, Louis Bordeaux, another interpreter who had been present at the meeting, told officers that Crazy Horse had not spoken as Grouard reported, and the matter should be straightened out.

Crook was busy assembling his command to go after the Nez Perce, but he agreed to meet

with Crazy Horse to clear up the confusion. As he and Clark were about to join Crazy Horse, Woman's Dress, an Indian scout and Red Cloud's nephew, told the interpreters that Crazy Horse planned to kill the officers during the meeting, then escape with his people and join Sitting Bull in Canada.

When the interpreters told Crook, he called off the meeting and telegraphed his command-ing officer, General Philip Sheridan, about Crazy Horse's alleged plan. Sheridan ordered Crook to place Crazy Horse under arrest, then to ship him in chains to a prison in the Dry Tortugas, sixty miles off the west coast of Florida. Crook relayed these orders to General Luther P. Bradley, who was in command of Camp Robinson, then departed for his cam-paign against the Nez Perce.

Sheridans Gates, immediately west of Spotted Tail Agency, north of Hay Springs, Nebraska

☙ THIRTEEN ❧

Life—and Death—at Camp Robinson

September 4, 1877

Hearing that he was to be arrested, Crazy Horse left his camp to take Black Shawl to stay with his parents at the Spotted Tail Agency. When Clark heard that Crazy Horse had gone, he sent four hundred of Red Cloud's agency Indians led by Red Cloud himself and eight full cavalry companies in pursuit. Rumors flew that some of the Indians would try to kill Crazy Horse when they captured him. Young-Man-Afraid went along to ensure that Crazy Horse was brought in safely.

When Crazy Horse arrived at the Spotted Tail Agency, he met with the agent, Lieutenant Jesse M. Lee, Spotted Tail, and his old friend Touch-the-Clouds. He told them he had never threatened to kill Crook. Now he only wanted to live in peace at the Spotted Tail Agency—away from his enemies at Red Cloud's Agency. Spotted Tail agreed to let Crazy Horse live at the agency, but only if he would obey his uncle's orders.

Lieutenant Lee, Spotted Tail, and Touch-the-Clouds agreed to accompany Crazy Horse to Camp Robinson so he could tell his side of the story. When the thousand men sent to arrest Crazy Horse arrived, the leaders met and decided to take Crazy Horse in the next day.

September 5, 1877

5:30 P.M.

After traveling all day, Crazy Horse and his escort arrived at Camp Robinson. He was asked to wait in the adjutant's office. Making his way through the crowd of Indians who had gathered, Lieutenant Lee went to confer with General Bradley at his residence across the parade ground.

Lee told the general he thought Crazy Horse had been wronged and that he would like to see the matter cleared up. Bradley brusquely informed Lee of the orders he had received, and said it was too late for explanations. He ordered Lee to put Crazy Horse in the guardhouse for the night, but to tell him that "not a hair of his head should be harmed."

6:00 P.M.

Lee returned to Crazy Horse. Thinking Bradley would talk with him the next day, Lee told Crazy Horse it was too late for them to meet, but that the general would see him in the morning. Lee put Crazy Horse in the charge of Captain Kennington, who would take him to a place where he could spend the night.

Kennington led Crazy Horse to the adjacent building and ushered him into a small room in the gloomy interior. Seeing the grated window and prisoners in shackles, Crazy Horse realized this was the jail.

Guardhouse (front) and adjutant's office (rear), Fort Robinson State Park, Crawford, Nebraska

6:05 P.M.

In panic, Crazy Horse drew a knife from his clothing and bolted for the door. He slashed at Kennington but the captain fended off the blow with his sword. Crazy Horse sprang through the doorway. Outside, Little Big Man, now an agency policeman, grabbed his arms to restrain him.

Trying wildly to get away, Crazy Horse cut into Little Big Man's wrist, making him lose his hold. Other Indian police rushed at Crazy Horse to restrain him as Kennington shouted, "Kill him! Kill him!"

Private William Gentles, who had been on guard duty outside the jail, lunged at Crazy Horse with his bayonet, plunging it deep into his right side.

Guardhouse door, Fort Robinson State Park, Crawford, Nebraska

6:10 P.M.

Crazy Horse sank to the ground. With a ragged sigh he said, "Let me go my friends, you have got me hurt enough."

Clock in guard's office, Fort Robinson State Park, Crawford, Nebraska

Adjutant's office, Fort Robinson State Park, Crawford, Nebraska

6:15 P.M.

A crowd of Indians surrounded Crazy Horse, stunned by what had happened. The ever loyal He Dog pushed his way through to Crazy Horse's side. Seeing that his friend was badly hurt, he removed the red blanket he was wearing and tenderly covered Crazy Horse with it.

Touch-the-Clouds and Dr. McGillicuddy also came to Crazy Horse's aid. The doctor determined that the wound was fatal. Touch-the-Clouds asked for permission to take Crazy Horse to an Indian lodge.

The doctor went to General Bradley. When he informed Bradley of Crazy Horse's condition and Touch-the-Clouds' request, Bradley said, "Please give my compliments to the officer of the day. He is to carry out his original orders and put Crazy Horse in the guardhouse."

Dr. McGillicuddy warned Bradley that the Indians were in a nasty mood; they did not want Crazy Horse to be put in the guardhouse. The general was firm.

When the doctor relayed the order and Kennington tried to move Crazy Horse into the jail, the Indians became more threatening.

Again, Dr. McGillicuddy went to Bradley. He told him that a lot of good people would die if Crazy Horse was put in the guardhouse, and suggested that he be taken to the adjutant's office instead. The idea displeased Bradley, but he realized it was the sensible thing to do.

6:30 P.M.

Crazy Horse's friends carried him into the adjutant's office. They were about to place him on a cot, but Crazy Horse asked to be laid on the floor. His friends spread blankets for him in a corner. Touch-the-Clouds was allowed to stay with him, though he had to surrender his gun. Crazy Horse's parents were summoned and soon arrived.

Window, adjutant's office,
Fort Robinson State Park, Crawford, Nebraska

141

7:00 P.M.–Midnight

Crazy Horse drifted in and out of consciousness throughout the evening while his parents and Touch-the-Clouds kept vigil. Once he asked for Lieutenant Lee. When he came, Crazy Horse grasped his hand and said, "My friend, I don't blame you for this. Had I listened to you this trouble would not have happened to me."

As they waited, Worm told Dr. McGillicuddy, "We were not agency Indians; we preferred the buffalo to the white man's beef, but the Grey Fox [Crook] kept sending messengers to us in the north saying, 'Come in, come in.' Well, we came in, and now they have killed my boy. Hard times have come upon us, but we were tired of fighting. Red Cloud was jealous of my boy. He was afraid the Grey Fox would make him head chief. Our enemies here at the agency were trying to force us away, so probably we would have been driven soon back to our hunting grounds in the north."

Louis Bordeaux was present as an interpreter. Crazy Horse let him know, "No white man is to blame for this. I don't blame any white man, but I blame the Indians. I don't wish to harm anybody but one person; he has escaped from me." Bordeaux knew he was referring to Little Big Man.

It was late when Worm leaned close to catch Crazy Horse's last whisper. "Ah, my father, I am bad hurt. Tell the people not to depend on me anymore now."

When Crazy Horse was gone, Touch-the-Clouds drew He Dog's blanket over his friend's face. He rose, his great height almost reaching the ceiling, and said, "The chief has gone above."

Room in adjutant's office where Crazy Horse died,
Fort Robinson State Park, Crawford, Nebraska

September 6, 1877

The next morning, his grieving parents put Crazy Horse's body on a travois and took it back to the Spotted Tail Agency. Near their camp on Beaver Creek, the body was wrapped in blankets and placed in a cottonwood tree. They left it there for two days.

Crazy Horse's body was then placed in a grave at the agency. His parents sat beside the grave night and day.

*Burial tree of Crazy Horse, on Beaver Creek,
north of Hay Springs, Nebraska. The tree, a cottonwood, has
been dead for many years; the trunk is supported by guy wires.*

October 27, 1877

Spotted Tail received orders to relocate his people to an agency north on the Missouri River. Before they left, Crazy Horse's parents took his body from its grave. One night during the move, they slipped away and buried it in a secret place.

It may be that Crazy Horse lies beneath the rocks at Scout Point on Beaver Creek.

Scout Point, near Beaver Creek, north of Hay Springs, Nebraska

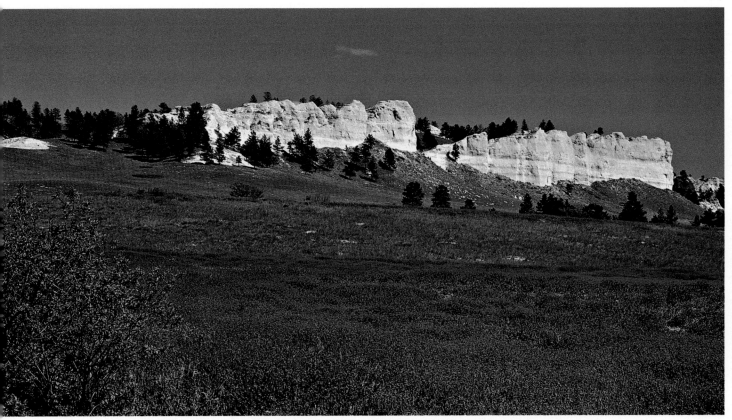

Bluffs along the valley of Wounded Knee Creek, near Manderson, South Dakota

Or perhaps his resting place is along Wounded Knee Creek beneath the White Buttes.

Or could it be that he is at peace somewhere
in the vastness of the Badlands?

Badlands National Park, South Dakota

It does not matter where his body lies; there the grass is growing. But where his spirit is, that would be a good place to be.

—Black Elk

Bibliography

Ambrose, Stephen E. *Crazy Horse and Custer.* Garden City, NY: Doubleday and Co., 1975.

Andrews, Ralph W. *Indians as the Westerners Saw Them.* Seattle: Superior Publishing Co., 1963.

Blish, Helen. Manuscript notes of an interview with Short Buffalo (Bull). July 23, 1929.

Bettelyoun, Mrs. Susan. Manuscript. Nebraska Historical Society.

Bourke, John G. *On the Border with Crook.* Reprint, Lincoln: University of Nebraska Press, 1971.

Brady, Cyrus Townsend. *Indian Fights and Fighters.* Reprint, Lincoln: University of Nebraska Press, 1971.

Brininstool, E. A. *Crazy Horse: The Invincible Oglala Sioux Chief.* Los Angeles: Wetzel Publishing Co., 1949.

———"How Crazy Horse Died." *Nebraska History Magazine,* Vol. 1, January-March 1929.

Brown, Vinson. *Great Upon the Mountain: Crazy Horse of America.* Healdsburg, CA: Naturegraph Publishers, 1971.

Buck, Daniel. *Indian Outbreaks.* Minneapolis: Ross and Haines, 1965.

Bull, Amos Bad Heart, and Helen Blish. *A Pictograph History of the Oglala Sioux.* Lincoln: University of Nebraska Press, 1967.

Byrne, P. E. *Soldiers of the Plains.* New York: Minton Balch and Co., 1926.

Camp, Walter. *Custer in '76.* Provo, UT: Brigham Young University Press, 1976.

Clark, Thomas O. *Frontier America, the Story of the Westward Movement.* New York: Charles Scribners' Sons, 1959.

Corbusier, William T. "Camp Sheridan, Nebraska." *Nebraska History Magazine,* vol. 1 (March 1961).

Crook, General George. *General George Crook, His Autobiography.* Edited and annotated by Martin F. Schmitt. Reprint, Norman: University of Oklahoma Press, 1946.

De Barthe, Joe. *The Life and Adventures of Frank Grouard.* Norman: University of Oklahoma Press, 1958.

Dockstader, Frederick J. *Great North American Indians: Profiles in Life and Leadership.* New York: Van Nostrand Reinhold Co., 1977.

Eastman, Charles A. *Indian Heroes and Great Chieftains.* Boston: Little, Brown and Co., 1918.

Finerty, John F. *War Path and Bivouac: The Big Horn and Yellowstone Expedition.* Reprint, Lincoln: University of Nebraska Press, 1966.

Fletcher, Alice C., and Francis La Flesche. *The Omaha Tribe.* Lincoln: University of Nebraska Press, 1972.

Graham, Col. W. A. *The Custer Myth: A Source Book of Custeriana.* Harrisburg, PA: Stackpole Co., 1953.

Gray, John S. *Centennial Campaign, The Sioux War of 1876.* Fort Collins, CO: Old Army Press, 1976.

Grinnell, George Bird. *The Fighting Cheyennes.* Reprint, Norman: University of Oklahoma Press, 1955.

Hassrick, Royal B. *The Sioux: Life and Customs of a Warrior Society.* Norman: University of Oklahoma, 1964.

Hebard, Grace Raymond. *Washakie.* Cleveland: Arthur H. Clark, 1930.

Hinman, Eleanor H. "Oglala Sources on the Life of Crazy Horse." *Nebraska History Magazine,* vol. 51 (Spring 1976).

Hoebel, E. Adamson. *The Cheyennes, Indians of the Great Plains.* New York: Holt, Rinehart and Winston, 1960.

Hunt, Dr. Lester C. *Orin Junction to Colorado Line.* Wyoming Writers' Project. New York: Oxford University Press, 1941.

Hyde, George. *Red Cloud's Folk: A History of the Oglala Sioux Indians.* Norman: University of Oklahoma Press, 1937.

———*Spotted Tail's Folk: A History of the Brulé Sioux.* Norman: University of Oklahoma Press, 1961.

———*Life of George Bent.* Norman: University of Oklahoma Press, 1968.

Jackson, Donald. *Custer's Gold: The United States Cavalry Expedition of 1874.* Reprint, Lincoln: University of Nebraska Press, 1972.

Johnson, Virginia Weisel. *The Unregimented General.* Boston: Houghton Mifflin, 1962.

Josephy, Alvin M., Jr. *The Patriot Chiefs.* New York: Viking Press, 1958.

———*The Indian Heritage of America.* Reprint, New York: Bantam Books, 1969.

Kadlecek, Edward, and Mabell Kadlecek. *To Kill an Eagle: Indian Views on the Last Days of Crazy Horse.* Boulder, CO: Johnson Publishing Co., 1981.

Knight, Oliver. "War or Peace: The Anxious Wait for Crazy Horse." *Nebraska History Magazine,* vol. 54 (Winter 1973).

Kuhlman, Charles. *Did Custer Disobey Orders at the Battle of the Little Big Horn?* Harrisburg, PA: Stackpole Co., 1957.

Larson, T. A. *History of Wyoming.* Lincoln: University of Nebraska, 1965.

Laubin, Reginald, and Gladys Laubin. *The Indian Tipi: Its History, Construction, and Use.* Reprint, New York: Ballantine Books, 1971.

Lee, Capt. Jesse M. Narrative. *Nebraska History Magazine,* vol. 19 (1929).

Lemly, H. R. *Death of Crazy Horse.* Sheridan, WY: Tepee Book, 1916.

Longstreet, Stephen. *War Cries on Horseback.* Garden City, NY: Doubleday and Co., 1970.

Mails, Thomas E. *Plains Indians, Dog Soldiers, Bear Men, and Buffalo Women.* Englewood Cliffs, NJ: Prentice Hall, 1973.

Marquis, Thomas B. *Wooden Leg: A Warrior Who Fought Custer.* Reprint, Lincoln: University of Nebraska Press, 1957.

———*Custer on the Little Big Horn.* Lodi, CA: Dr. Marquis Custer Publications, 1967.

Mears, David T. "Campaigning Against Crazy Horse." Proceedings and collections of the Nebraska State Historical Society, vol. 15 (1907).

Moeller, Bill, and Jan Moeller. *The Oregon Trail: A Photographic Journey.* Wilsonville, OR: Beautiful America Publishing Co., 1985.

Murray, Robert A. *Military Posts in the Powder River Country of Wyoming 1865–1894.* Lincoln: University of Nebraska Press, 1968.

Neihardt, John G. *Black Elk Speaks.* New York: William Morrow and Co., 1932.

Nelson, Bruce. *Land of the Dacotahs.* Reprint, Lincoln: University of Nebraska Press, 1946.

Nurge, Ethel. *The Modern Sioux: Social Systems and Reservation Culture.* Lincoln: University of Nebraska Press, 1970.

Olson, James C. *Red Cloud and the Sioux Problem.* Lincoln: University of Nebraska Press, 1965.

Parsons, John E., and John S. du Mont. *Firearms in the Custer Battle.* Harrisburg, PA: Stackpole Co., 1953.

Peters, Joseph P. *Indian Battles and Skirmishes on the American Frontier 1790–1898.* New York: Argonaut Press, Ltd., 1966. Published for University Microfilms, Ann Arbor, MI.

Potomac Corral of Westerners. *Great Western Indian Fights.* Lincoln: University of Nebraska Press, 1960.

Ricker, Judge E. S. Tablets. Nebraska Historical Society.

Sandoz, Mari. *Crazy Horse, The Strange Man of the Oglalas, A Biography.* Reprint, Lincoln: University of Nebraska Press, 1961.

————*The Battle of the Little Big Horn.* Reprint, Lincoln: University of Nebraska Press, 1966.

————*The Great Council.* Crawford, NE: Cottonwood Press, 1970.

————Collection. Love Memorial Library. University Archives/Special Collections. University of Nebraska Libraries, Lincoln.

Scudder, Ralph E. *Custer Country.* Portland, OR: Binfords and Mort, Publishers, 1963.

Smith, Sherry L. *The Bozeman Trail.* The Wyoming Department of Environmental Quality with the Wyoming State Historic Preservation Office to study the Bozeman Trail.

Sneve, Virginia Driving Hawk. *The Dakota Heritage.* Sioux Falls, SD: Brevet Press, 1973.

Speer, Elsa. *Bozeman Trail Scrapbook.* Sheridan, WY: Printed by the Mills Co., 1967.

Spring, Agnes Wright. *Caspar Collins.* New York: Columbia University Press, 1927.

Standing Bear, Luther. *My People the Sioux.* Reprint, Lincoln: University of Nebraska Press, 1928.

Tebbel, John. *The Compact History of the Indian Wars.* New York: Hawthorne Books, 1966.

Tillett, Leslie. *Wind on the Buffalo Grass: The Indians Own Account of the Battle of the Little Big Horn and the Death of their Life on the Plains.* New York: Thomas Y. Crowell Co., 1976.

Trenholm, Virginia Cole. *Footprints on the Frontier.* Douglas, WY: Douglas Enterprise Co., 1945.

————and Maurine Carley. *The Shoshonis: Sentinels of the Rockies.* Norman: University of Oklahoma Press, 1964.

————*The Arapahoes, Our People.* Norman: University of Oklahoma Press, 1970.

Urbank, Mae. *Wyoming Place Names.* Boulder, CO: Johnson Publishing Co., 1974.

Utley, Robert M. *Custer and the Great Controversy.* Los Angeles: Westernlore Press, 1962.

————*Frontier Regulars: The United States Army and the Indian 1866–1891.* New York: Macmillan Publishing Co., 1973.

Vestal, Stanley. *New Sources of Indian History 1850–1891.* Norman: University of Oklahoma Press, 1934.

————*Sitting Bull, Champion of the Sioux: A Biography.* Reprint, Norman: University of Oklahoma, 1957.

———*Warpath: The True Story of the Fighting Sioux Told in a Biography of Chief White Bull*. Reprint, Lincoln: University of Nebraska Press, 1984.

Vice, Mari A. *Billings, Montana, to Belle Fourche, South Dakota: A Geologic Road Log Along Interstate 90 and U. S. 212*. Montana Geological Society, 1976.

Walker, James R. *Lakota Belief and Ritual*. Lincoln: University of Nebraska Press, 1980.

———*Lakota Society*. Lincoln: University of Nebraska Press, 1982.

Webster's American Military Biographies. Springfield, MA: G. and C. Merriam Co., 1978.

Weems, John Edward. *Death Song: The Last of the Indian Wars*. Garden City, NY: Doubleday and Co., 1971.

Wellman, Paul I. *Death on the Prairie*. New York: Macmillan, 1934.

Werner, Fred H. *Before the Little Big Horn: Battle of the Rosebud, Montana Territory, June 17, 1876*. Greeley, CO: Werner Publications, 1980.

———*The Slim Buttes Battle, September 9–10, 1876*. Second edition. Greeley, CO: Werner Publications, 1981.

———*Faintly Sounds the War Cry: The Story of the Battle Butte Fight, January 8, 1877*. Greeley, CO: Werner Publications, 1983.

Wheeler, Col. Homer W. *Buffalo Days*. Indianapolis: Bobbs-Merrill Co., 1925.

Index

About the Authors

Husband and wife Bill and Jan Moeller are professional photographers and authors. Since 1982 they have traveled full-time in their RV to photograph historical sites around the United States. Having their home with them allows the Moellers to stay in an area as long as necessary to take pictures and do research for their unique photographic history books.

Before embarking on their land-based ventures, the Moellers lived aboard a sailboat for twelve years. In addition to their photo histories, the authors have published two successful volumes on sailing and three on RV travel, as well as writing a syndicated newspaper column called "RV Traveling." Other full-color history titles by the Moellers published by Mountain Press include the popular *Chief Joseph and the Nez Perces: A Photographic History* and *Lewis and Clark: A Photographic Journey*.

OTHER BOOKS BY BILL AND JAN MOELLER

Chief Joseph and the Nez Perces:
A Photographic History

Lewis and Clark:
A Photographic Journey

The Oregon Trail:
A Photographic Journey

Custer, His Life, His Adventures:
A Photographic Biography

The Intracoastal Waterway:
A Cockpit Cruising Handbook

Living Aboard:
The Cruising Sailboat as a Home

A Complete Guide to Full-time RVing:
Life on the Open Road

RV Electrical Systems

RVing Basics

We encourage you to patronize your local bookstore. Most stores will order any title that they do not stock. You may also order directly from Mountain Press using the order form provided below or by calling our toll-free number and using your MasterCard or VISA. We will gladly send you a complete catalog upon request.

Some other titles of interest:

_____*Crazy Horse: A Photographic Biography*	$20.00/paper	
_____*Lewis & Clark: A Photographic Journey*	$18.00/paper	
_____*The Journals of Patrick Gass:*		
Member of the Lewis and Clark Expedition	$20.00/paper	$36.00/cloth
_____*Chief Joseph and the Nez Perces:*		
A Photographic History	$15.00/paper	
_____*Lakota Noon:*		
The Indian Narrative of Custer's Defeat	$18.00/paper	$36.00/cloth
_____*Children of the Fur Trade:*		
Forgotten Métis of the Pacific Northwest	$15.00/paper	
_____*The Piikani Blackfeet: A Culture Under Siege*	$18.00/paper	$30.00 cloth
_____*William Henry Jackson: Framing the Frontier*	$22.00/paper	$36.00 cloth

Please include $3.00 per order to cover shipping and handling.

Send the books marked above. I enclose $ _____

Name _____

Address_____

City/State/Zip _____

☐ Payment enclosed (check or money order in U.S. funds)

Bill my: ☐ VISA ☐ MasterCard Expiration Date:_____

Card No._____

Signature _____

MOUNTAIN PRESS PUBLISHING COMPANY
P.O. Box 2399 • Missoula, MT 59806 • fax: 406-728-1635
Order Toll Free 1-800-234-5308 • Have your VISA or MasterCard ready.
e-mail: mtnpress@montana.com • website: www.mountainpresspublish.com